THE MAKING OF A COLLECTION

THE MAKING OF
A COLLECTION

PHOTOGRAPHS FROM
THE MINNEAPOLIS
INSTITUTE OF ARTS

BY CARROLL T. HARTWELL

A P E R T U R E
Visual Studies Workshop
Research Center
Rochester, N.Y.

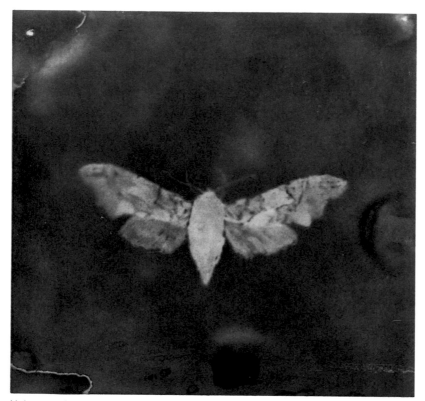

Unknown photographer, n.d.

THIS BOOK IS DEDICATED TO
THE MEMORY OF ANTHONY MORRIS CLARK
WHOSE EXAMPLE AND GUIDANCE CONTINUE AS THE MOST
PERSISTENT FORCE IN MY PROFESSIONAL LIFE.

THE MAKING OF A COLLECTION

CARROLL T. HARTWELL

It has almost become a cliché to say that the most inter-
esting collections have been formed along lines that, like
their creators, are predisposed to specific tastes or con-
cerns and are, as a result, more or less "eccentric." An ob-
vious extension of this value judgment suggests that a col-
lection would be diminished in character or thrust if it
lacked these subjective features, if the personality of the
collector, per se, were missing. The history of photography,
in particular, is rich with instances where the intelligence
and cleverness of the individual collector have given sub-
stance to our understanding of the beauty and singularity of
the medium.

During the last thirty-five years, the collecting of photo-
graphs has been, it seems, legitimized through the sanction
and endorsement of the Art Institute of Chicago, the Bos-
ton Museum of Fine Arts, The Museum of Modern Art,
and, even earlier, the Metropolitan Museum of Art and the
Albright-Knox Art Gallery. More recently, New Orleans,
Houston, Detroit, and Minneapolis have followed similar
patterns of acquisition. In each instance, these collections
have almost always been the result of the decisions and
convictions of a single person, usually a curator. And most
importantly, the creators of these younger collections have
all had the advantage of being able to look at four key peo-
ple in the field whose aesthetic insight and art historical
acumen have been exemplary: Beaumont Newhall of
George Eastman House, John Szarkowski of The Museum
of Modern Art, Hugh Edwards of the Art Institute of Chica-
go, and, of course, Alfred Stieglitz himself, the father of
modern photography, whose collection of American and
European photographs was the basis for the Metropolitan's
holdings.

The pattern of autonomy that any one of these cura-
tors exercises is as real and important as that which exists
for a private collector. Trustee committees and influential
donors not withstanding, these museum professionals

shape, guide, exhibit, and publish their assemblages ac-
cording to their own judgments and proclivities. For better
or worse, the photography collection at The Minneapolis In-
stitute of Arts has been formed according to one individu-
al's knowledge and biases—my own.

A certain misreading of this institution's historical flirta-
tion with photography has resulted from Minneapo-
lis's failure to publicly trace its origins. As early as
1903, the Minneapolis Photographic Salon published and
exhibited works by its members together with those by in-
vited photographers of national and international repute. In-
deed, it is a matter of record that one of the first loan exhi-
bitions organized by Alfred Stieglitz of his New York-based
Photo-Secessionists was created expressly for Minneapolis
and shown alongside 250 works done in the same impres-
sionistic spirit by photographers of the Minneapolis area.
This event signaled the beginning of what later became an
ongoing exhibition program conducted by the Minneapolis
Camera Club, which continued well into the mid–1950s.

But curiously, it was not until 1983 that any examples
from these early exhibitions were to enter the museum's
permanent collection. This is not to disparage or impute the
judgment of the Institute's staff at the time, but merely to
suggest that photography—as a highly popular craft and di-
version with no true history as art—was not considered an
appropriate medium to accession. While The Minneapolis
Institute of Arts, along with most American museums in
the 1930s and '40s, exhibited photographs—usually loan
exhibitions from local camera clubs—it had no in-house col-
lection of them. It seems probable that photography, lack-
ing the scholarly, art historical, and museological underpin-
nings that painting and sculpture already possessed, simply
was not considered worthy.

Without pressing the point too far and not to make

Minneapolis appear exceptional in its failure to collect photographs during these years, it should be noted that in 1910 the Albright Gallery in Buffalo, New York (later to become the Albright-Knox) mounted the largest display of photographic art to date. Curated by Stieglitz, it occupied all of the museum's galleries and included 479 framed items. Writing at the time to an amateur photographer in Germany, Stieglitz stated:

> The exhibition made such a deep artistic impression that the trustees bought twelve pictures for very good prices, and even set apart a gallery for them. This space will remain a permanent home for pictorial photography. The dream I had in Berlin in 1885 has finally become a reality.[1]

But while the museum did not keep its promise to provide a permanent exhibition space for photography, it had indeed purchased original prints by Edward Steichen, Clarence H. White, Gertrude Käsebier, and Heinrich Kuehn, as well as by such lesser known names as the Scottish photographers David Octavius Hill and Robert Adamson.[2] Moreover, another fourteen years would elapse before the next notable acquisition of photographs would be made by a major American museum. This was in 1924 when Ananda Coomaraswamy accepted a gift of twenty-seven photographs from and by Alfred Stieglitz for the Boston Museum of Fine Arts.

During the first months of 1963, the loan requests for Carl Weinhardt's "Four Centuries of American Art" were sent out and began to form what proved to be an immensely popular and substantial exhibition, which opened at the Institute that November and lasted through the middle of January 1964. As museum photographer, I was responsible for making object photographs for the accompanying catalogue. The exhibition's paintings, sculpture, silver, and furniture—which so eloquently expressed an artistic and craft heritage that was distinctly American—provoked me to observe to Weinhardt, then the museum's director, that a serious gap was left by the omission of American photography. Were we, in our intended comprehensiveness, to ignore Alfred Stieglitz, Edward Steichen, Lewis Hine, Ansel Adams, Edward Weston, Walker Evans, W. Eugene Smith, and Robert Frank? I subsequently proposed that I be allowed to spend sufficient time, first in New York City at the Metropolitan and The Museum of Modern Art, then in Rochester, New York, at George Eastman House, and lastly in Chicago at the Art Institute, to enable me to study the photography collections held by these great museums. And—most audacious of all—that I be permitted to borrow from these collections to put together a corollary exhibition to Weinhardt's survey, which I called "A Century of American Photography."

It is impossible to construct a more privileged beginning for an aspiring curator of photography than to visit the Stieglitz Collection at the Metropolitan Museum of Art. The collection—580 photographs assembled by Stieglitz between 1894 and 1911 and given to the museum in 1933 as a gift and in 1949 as a bequest—represents, in Stieglitz's own words, "the very best that was done in international pictorial photography upwards of seventy-odd years"[3] and includes fifty Steichens, fifty Clarence Whites, and fifty Frank Eugenes. At the time of my visit, however, it was so little used that in several instances sequences of prints that I had arranged and then reshelved went virtually undisturbed for several months. I was able, therefore, to fully immerse myself in the material for the two weeks I spent there. This, coupled with frequent discussions with Hyatt Mayor, then the curator of prints and photographs, set the pattern and tone for my independent study, a study that next took me to The Museum of Modern Art.

The photography collection at The Museum of Modern Art covers the entire history of the medium and is particularly strong in the area of twentieth-century work. In 1963, John Szarkowski had been director of the department for nearly a year and Steichen was routinely present, offering his paternalistic insight into the collection. Grace Mayer's omniscient and patient custodianship as curator, too, helped to create an atmosphere of calm and order that was highly conducive to my becoming familiar with the many prints and their makers. Indeed, the advantages of working with three such original people and such a wealth of photographs can hardly be overstated.

As if these two experiences were not sufficient, I then moved on to Rochester for a week. The International Museum of Photography at George Eastman House, which opened in 1949 and is one of the primary research centers for photography in the world, possesses over 600,000 items documenting the history and aesthetics of photography and in addition to its collection of photographs holds

large numbers of photographic equipment, motion-picture films, and film stills. At the time, Beaumont Newhall was the director and Nathan Lyons the curator, and both were as supportive and encouraging as one could hope for and along with Robert Doty, then a graduate intern, provided guidance through the intricacies of that amazing collection.

My last stop was Chicago. A collection of photographs was initiated at the Art Institute in 1949 with a generous gift of 200 photographs from Georgia O'Keeffe—150 photographs and photogravures by her late husband Alfred Stieglitz and fifty prints by various members of his Photo-Secession. Over the next several years, by gift and purchase, works by Weston, Ansel Adams, and Harry Callahan were added to the collection as well as images by Henri Cartier-Bresson, Brassaï, and Weegee. In 1959, Hugh Edwards, who had worked at the museum since 1927, was appointed as curator of photography, and it was he who became my nearest and most frequent professional contact. Through a passionate flow of thought and reasoning, he led me to understand the visual and historical connections between Stieglitz and Minor White, Walker Evans and Robert Frank, Weston and Joseph Jachna. Hugh's inherent powers of discrimination, as well as his unswerving taste and judgment, continue to provide a model for the functioning of a proper curator and connoisseur.

The result of this brief, but intensive, study was the exhibition "A Century of American Photography 1860–1960," which opened at the Institute in November 1963. It consisted of 125 photographs drawn from the above-mentioned institutions and featured work by thirty-six photographers, including Thomas Eakins, Stieglitz, Alvin L. Coburn, Man Ray, Charles Sheeler, Lewis Hine, Evans, and Frank. An assortment of contemporary photographers—among them George Krause and Aaron Siskind—was included. In fact, the selection was as broad in historical scope and aesthetic type as could be reasonably hoped for in so limited a number of examples. Even now, as I review the checklist of the show, it occurs to me that with a bit of updating I would be altogether happy to do the same exhibition again today.

A second exhibition, utilizing loans from these same museums and artists, opened the following spring in the six main galleries of the museum. Entitled "The Aesthetics of Photography: The Direct Approach," it attempted to demonstrate systematically that in its unaltered and most basic technical application the photograph does provide a

vehicle for personal artistic expression and as such can be said to have a distinct aesthetic character all its own.

These two shows, then, signaled the beginning of an exhibition program that has continued unabated since 1964. At first, starting with an installation of Tom Muir Wilson's solarized and toned images in December 1965, there was a series of one-person exhibitions that alternated between historical material (e.g., that of the Victorian photographer Charles Currier or of the Photo-Secession) and contemporary works produced by photographers working in Minneapolis (e.g., Danny Seymour, Elaine Mayes, Gary Hallman, Stuart Klipper, and Robert Wilcox). For much of the former, it was still possible with relative ease and little expense to draw upon the museum collections with which I had become acquainted.

At this point, however, The Minneapolis Institute of Arts still had no collection of photographs of its own. In the absence of funds for purchase and with no clear policy for the future, several acquisition opportunities were lost. One such opportunity arose during my visit in 1964 to Berenice Abbott's tiny East Village apartment to borrow prints for "A Century of American Photography." We sorted through many boxes of her work on top of and around an enormous crate situated in the middle of her living room. It took little encouragement for her to reveal that the crate was filled with prints and glass plates by Eugène Atget. Berenice asked, "Would your museum be interested in buying the entire collection?" But while I plead the case for Minneapolis purchasing all of this uncatalogued and relatively obscure French material, the Atget acquisition turned out to be a futile dream on my part. The material— now known as the Abbott-Levy Collection—was subsequently acquired by The Museum of Modern Art in 1968 where for the past fifteen years it has been organized, exhibited, and published with a thoroughness that would have been well beyond the Institute's capacity.

However, during that same trip, I also called the museum's director for permission to send a set of old photo magazines for consideration, which cost five hundred dollars. This set of Stieglitz's quarterly, *Camera Work,* had been listed in the Wehye Bookstore's periodical for more than a year and was evidently not all that coveted. But in truth, once the newspaper-wrapped set was in Minneapolis and duly presented to the director and staff, it was without

question a most defensible purchase. Here seemed to be Minneapolis's own modest version of the Stieglitz Collection, and I would employ it and its contents in much the same way as I had the Metropolitan's. It was possible, with this set of *Camera Work* as a foundation, to imagine the beginnings of a collection, for that same year the offer of a perfect Edward Weston *50th Anniversary Portfolio* came from a local photographer. An embarrassingly small sum consummated the transaction and along with the Ansel Adams *Portfolio Number Three* (1960), purchased from the Carl Siembab Gallery in Boston, we had a total of thirty photographic prints.

One afternoon in 1969, Julia Marshall, a Duluth resident and occasional professional portrait photographer, walked into my office, put several copies of *Camera Work* into my hands, and said, "Do you know what these are?" Her frustration at not being able to find a proper home for this treasure—which had been carefully stored away in her attic for almost fifty years—was immediately soothed when she learned that we not only knew what the material was, but would gratefully accept it as a gift to the museum. In fact, it could be said that the photography collection at The Minneapolis Institute of Arts was inspired by the abiding interest in the medium that Julia Marshall has had since her student days in New York in the '20s. Her teacher Clarence H. White was evidently the source for both her contact with Stieglitz and for her understanding of the crucial position that *Camera Work* held—and continues to hold—in the history of American art and photography.

These wonderful volumes, then, with their perfectly executed gravures of images by White, Käsebier, Joseph T. Keiley, A. L. Coburn, and Steichen, as well as by Stieglitz himself, were and remain the cornerstone of The Minneapolis Institute of Arts' collection of photographs. Not only was this gift an inspired and fortuitous beginning for the museum's collection, but its spirit and example (that of both Stieglitz and Julia) have been the touchstone and foundation for all of the photographs added since. In precisely the same way that Stieglitz used *Camera Work* and his galleries to present American photography as a vital aspect of the avant-garde, The Minneapolis Institute of Arts' collection and exhibition program have typically reflected a devotion to contemporary artists' work, ideas, and accomplishments. True to Stieglitz's practice of providing a historical base for his readers (e.g., issues featuring David Octavius Hill, Frederick H. Evans, and Julia Margaret Cameron), this collection, too, has been founded on the principle that contemporary photography is a valid addition to the aesthetic and technical development of the medium to the extent that it takes cognizance of and builds on its history.

Suddenly, then, with Julia's gift, we had two sets of *Camera Work*. It never once occurred to me, even with escalating market values, to consider selling off the first set. Instead, it became possible to keep it intact (except for 49/50) and from Julia's set to selectively remove and frame a substantial number of the gravures themselves. These then became the foundation for loan exhibitions that have traveled widely to places as diverse as Tempe, Arizona; Fort Dodge, Iowa; Vermillion, South Dakota; and Williamstown, Massachussetts.

For the next several years, *Camera Work* continued to be the center of our still-modest collection. In 1973, however, another unsolicited gift was offered, this time of Lee Friedlander's portfolio *Fifteen Photographs*. The anonymous donor could hardly have anticipated the significance of his gift and how it would prefigure in the collection's changing emphasis. Had he known that Friedlander's images would be the occasion for my reassessment of Stieglitz, Atget, and Walker Evans, as well as for what I thought about photographic picture making in general, he might have hesitated, but probably not. Such is the unforeseeable consequence of donations.

Soon thereafter, in 1974, the Robert Wilcox Collection was purchased, which contains virtually all of this Minnesota photographer's work. His career was halted abruptly by his tragic death in 1970, but we are able to trace its development over a period lasting more than a decade. Wilcox's photographs, often reminiscent of the work of Paul Strand or Walker Evans in their formal poise, are firmly rooted within the documentary tradition. The most extensive group is from his series on the "Gateway Area" of Minneapolis, the city's own version of "skid row," which was torn down in the late 1950s and '60s during the first great wave of urban renewal.

By now, the philosophy and artistic polarization of the collection were becoming evident. With the 1975 acquisition of more than seventy photographs by Walker Evans, another primary dimension emerged. Once again, gifts to the collection had a crucial and formative effect. Arnold H. Crane from Chicago and D. T. Bergen from London, who was a former trustee of the Institute's, each made donations of Evans prints to the museum. These were judiciously selected to complement yet another group of Evans photographs that were purchased at about the same time.

Together, these acquisitions represented the largest single addition of photographs to the collection to date. Interestingly, the Evans pictures now stood within the collection as a type of bridge extending from Atget's images of the early 1900s through to Evans's own photographs of America in the '30s, and on to Friedlander's of the 1960s.

Remarkably, that same year the museum acquired a group of 5 x 7-inch contact prints by another great documentarian, Lewis W. Hine. Some seventy in number, they were literally rescued from the files of the National Child Labor Committee in Washington, D.C. The University of Maryland Baltimore County Library was given the entire Hine collection by the federal government with the understanding that duplicate prints could be sold. It was through this arrangement that we were able to buy our selection.

Over the past nine years, an extraordinary range of artists' work has been added by purchase and donation. Images by such masters as Atget, Steichen, Strand, and Minor White have been secured as well as prints by August Sander, Weegee, Diane Arbus, and Richard Avedon. Photographs by more contemporary workers have also been accessioned and include examples by William Christenberry, Reed Estabrook, Frank Gohlke, Richard Misrach, and Nicholas Nixon. Curiously, the most recent and spectacular acquisition—of two Stieglitz silver prints, *Equivalent* (1929) and *From the Shelton, West* (1935)—has brought the collection full circle to its origins in two sets of *Camera Work*.

Having quickly recounted the history of the collection's formation, I would like to offer some advice to would-be collectors of photographs, with, of course, a certain generosity toward amendment and exception.

Don't throw anything away. Stieglitz, the great private collectors André Jammes and Julien Levy, among many others, cite instances where, in a moment of precipitous orderliness or disregard, things were discarded that could have provided illumination or connection in ways realized only after they were gone. Save Bill Dane's photo-postcards as well as Gene Thornton's review of Cindy Sherman's last exhibition at Metro Pictures.

Look at and consider every image you can. If you assume that photographs made with a motorized Minolta can't be *Art,* there is as much risk of tunnel vision as if you were to conclude that all of Edward Weston's prints are by definition quintessential.

Consider everything. Gauge, speculate, and wait. There is a fair chance that the true value of a photograph will emerge, or that its ultimate rejection will proceed from its own inherent inadequacies.

Question the authoritative pronouncement. If Janet Malcolm seems correct, then how about Susan Sontag on the subject of Arbus or Avedon? If John Szarkowski's reading of William Eggleston's color pictures is sufficient, then what about his view on Irving Penn's platinum prints of cigarette butts? If Avedon is purported to be simply applying a commercially successful formula to his portraits, then what can be said of his absolutely galvanizing images of his father, Jacob Israel Avedon? And if Bruce Downes assigns Robert Frank's *Americans* to the category of misanthropic perversity, then how are we to interpret the effects of Frank's book on a generation of photographers and a world of photographically attuned and sensitive viewers?

One of the lures and dangers of being a curator or a collector is that it engenders a tendency toward compulsiveness, a truly insatiable appetite for the next picture, the next image that you simply must have and without which the collection will not be complete. For such a collector, it is always a new photograph, an unknown or unacknowledged artist, a reassessment of known but undervalued works, or a novel synthesis or juxtaposition of material that yields added insights and fresh desires. The mosaic that the collection already is will certainly be extended, but in defiance of the knowledge that a kind of completeness has already been achieved. Yet there is no stopping short of renouncing collecting altogether. This is not likely to be a satisfactory solution, however, and for the museum curator, it is not only contrary but fatal to the reasons for which one enters the museum field in the first place. For what Susan Sontag writes about the making of photographs could also be said about collecting them:

> The final reason for the need to photograph everything lies in the very logic of consumption itself. To consume means to burn, to use up—and, therefore, to need to be replenished. As we make images and consume them, we need still more images; and still more. But images are not a treasure for which the world must be ransacked; they are precisely what is at hand wherever the eye falls. The possession of a camera can inspire

something akin to lust. And like all credible forms of lust, it cannot be satisfied: first, because the possibilities of photography are infinite; and, second, because the project is finally self-devouring.[4]

To sidestep any dour inference from Sontag and to dispel the suspicion that collecting may be nothing more than a self-indulgent obsession, I'd like to relate a story about a very special collection and the people who created it: the Gale Collection of Japanese prints and paintings, which was received by the Institute in 1974.

As the museum's photographer, I had the special privilege of working with Dick Gale and his extraordinary wife Pete (née Isobel) at their farm in Mound, Minnesota, during the long and harsh winter of 1967, producing a complete and affectionate record of their collection of Ukiyo-e woodcuts and hanging scrolls. The color transparencies and black-and-white prints that came out of our labors took the form of a two-volume book by Jack Hillier that is both a testimony to the quality of the collection and, more importantly, a tribute to the passion and care with which it was assembled.

Thinking back to that special four-month project, I believe now that I have a better idea of how the experience entered into and materially conditioned both my attitude and sense of discrimination when it comes to collecting. Here, for the first time, I came across flesh-and-blood models whom I liked and respected, connoisseurs who interacted with the professional and scholarly community at large and added that expertise to their own. Most significantly, they were always reforming and redefining their collection, constantly trading up to eventually possess the very finest possible. As Dick would say, "It's all the same thing [collecting Japanese art or American photography]; trust your eyes and get it." Moreover, the example of this spirit introduced me to what is finally the best reason for collecting—the essential humbling and civilizing effect of the art itself as a consequence of the intelligence and skill of its maker.

An assemblage of work, objects, or things only becomes a collection by reason of the collector's knowledge, selectivity, and insight. To be touched by the spirit and grace of the object is surely the purpose of our desire to collect and its fulfillment. In both its individual parts and aggregate, the collection does justice to these motives and enthusiasms, reflecting them tangibly and usefully. It instructs and delights, is propitious and a pleasure.

What has seemed to be photography's most apparent and characteristic feature—its capacity to delineate appearances—has proven to be less than factually complete, yet more than mere record. That its technical foundations derive from chemical and optical sciences has, from the start, suggested authentic translation, verifiable depiction, and factual accuracy. The seductiveness of this notion, which satisfies our impulse to obtain a predictable reality, has always brought with it the awareness that beyond the surface "facts" are the poignancy and poetry of evocation. The photograph seems always to exceed the boundaries of its nominal subject and to attempt to unite the observer and the observed.

The earliest photographic pictures hold us by virtue of their distance in time, and the nostalgia and reminiscence that distance allows. They often function as icons of an aesthetically viable and archetypal past. By a direct, simple, and seemingly tentative means (technical and artistic), they speak of a wonderment and an allure that we assume was also embraced by the first photographers who, like us, believed in their veracity, authority, and fidelity as pictures. The idea that the photograph was a faithful recorder of reality is suggested by Julia Margaret Cameron's statement: "I longed to arrest all beauty that came before me, and at length the longing has been satisfied."[5]

In fact, the accommodations we make for the shortcomings of photography as an instrument of strict objectivity are the basis for its most useful application as metaphor and translation. Like vision itself, the photograph embodies our expectations and desires, our wished-for realities and illusions of fact.

Where photography surpasses itself is at the point where its subjects help us to better understand ourselves. Statement and meaning proceed from the photographer's attempts to isolate and portray salient visual features. But the photograph's ultimate relevance and cogency depend on the photographer's intentions and the limits placed on the subject. In photography, as John Szarkowski has written, "form and subject are defined simultaneously. Even more than in the traditional arts, the two are inextricably tangled. Indeed, they are probably the same thing. Or, if they are different, one might say that a photograph's subject is not its starting point but its destination."[6]

Several years ago, an enormous exhibition was mounted in Cologne: "The Imaginary Photo Museum: Fiction and Realization." Apart from the implicit contradiction in terms of its title, it suggested that the assembled pictures, if kept

together, would constitute the ideal and presumably exhaustive distillation of what photography has been, is, and even could be in the future. In that single exhibition, its history, its main artistic features, and its current trends were lucidly represented in photographs that had been drawn from many of the most substantial and highly esteemed collections, American and European, public and private.

Yet despite the scope of this valiant and seemingly all-encompassing enterprise, it possessed a major flaw. The ideal museum of photography could only be a magnificent emporium containing all of George Eastman House, The Museum of Modern Art, the several existing Stieglitz collections, Bill Larson's Moholy–Nagy collection, Jan Leonard's and Jerry Piel's Grand Tour photographs, and much, much more. For the ideal museum—the truly comprehensive collection—will always be an insatiable desire, an ambition beyond fulfillment.

The folly and fallacy of such an all-encompassing collection is that, if obtained (which in theory it cannot be), it would put an end to all of those profoundly human meanings that inform and give life to any artistic activity, including collecting. A collection never simply "is." All the bases can never be covered; the full results can never be in.

The intellectual and cultural crosscurrents that shape the knowledge, texture, and demeanor of an era are the same forces that flow through and enliven all that we value of that culture and by which our own age is formed and known. In collecting, the task is, of course, to decide what things to save. To put a finer, more personal point on this philosophy, I quote the following:

> Those of us who live by our eyes—painters, designers, photographers, girl-watchers—are both amused and appalled by the following half-truth: "What we see, we are"; and by its corollary: "Our collected work is, in part, shameless, joyous autobiography *cum* confession wrapped in the embarrassment of the unspeakable."[7]
>
> WALKER EVANS

> It is always the instantaneous reaction to oneself that produces a photograph.[8]
>
> ROBERT FRANK

The photography collection at The Minneapolis Institute of Arts represents one more entry on the subject of how photographs partake of such a cultural and personal consciousness and thereby mirror it.

I mean to encourage the reader of this book to consider these images and the order in which they occur as a provisional offering of subjective and suggestive intention. Phrased otherwise, understand them as a personal response and statement by one curator about an immensely complex and unsettled field of visual discourse and expression. And remember always that the proposition is open-ended.

The pictures in this catalogue are sequenced in a way intended to be provocative and emblematic. They take cognizance of a historical progression (but this is not primary) and allude to different kinds of photographs that are at once artistically sufficient in themselves yet stand relative to their antecedents visually, formally, and culturally. How each one fits into this scheme is to be discovered by the viewer. While the evidence is all there and each photograph is the receptacle and vehicle for this extrinsic relationship, the extent to which each person understands all of these levels is largely dependent upon his or her individual perception, generosity of spirit, and knowledge about the history of photography and the cultures that created it.

Finally, I would like to believe that the photography collection that I have been assembling for Minneapolis over the past two decades approximates what was once said about Hyatt Mayor's lectures: "[They] are constructed like the very best Parisian roasts—whose butchers slip pistachios into the veal—providing oblique, piquant perspectives, relishing the flavor of the past"[9] and, I might add, the present.

1. Quoted in Beaumont Newhall's essay "Museums and Photography" in Renate and L. Fritz Gruber, *The Imaginary Photo Museum* (New York: Harmony Books, 1982), p. 9.

2. *Ibid.*

3. Quoted in Weston J. Naef, *The Collection of Alfred Stieglitz: Fifty Pioneers of Modern Photography* (New York: The Metropolitan Museum of Art, 1978), p. 8.

4. Susan Sontag, *On Photography* (New York: Delta Publishing Co., 1973), p. 179.

5. *Ibid,* p. 183.

6. John Szarkowski, *William Eggleston's Guide* (New York: The Museum of Modern Art, 1976), p. 7.

7. Quoted in Beaumont Newhall, ed., *Photography: Essays & Images* (New York: The Museum of Modern Art, 1980), p. 312.

8. Quoted in Vicki Goldberg, ed., *Photography in Print: Writings from 1816 to the Present* (New York: Simon and Schuster, 1981), p. 401.

9. A. Hyatt Mayor, *Selected Writings and a Bibliography* (New York: The Metropolitan Museum of Art, 1983), p. 21.

The history of photography has been less a journey
than a growth. Its movement has not been linear
and consecutive, but centrifugal. Photography, and
our understanding of it, has spread from a center; it
has, by infusion, penetrated our consciousness. Like
an organism, photography was born whole. It is in
our progressive discovery of it that its history lies.

JOHN SZARKOWSKI, 1966

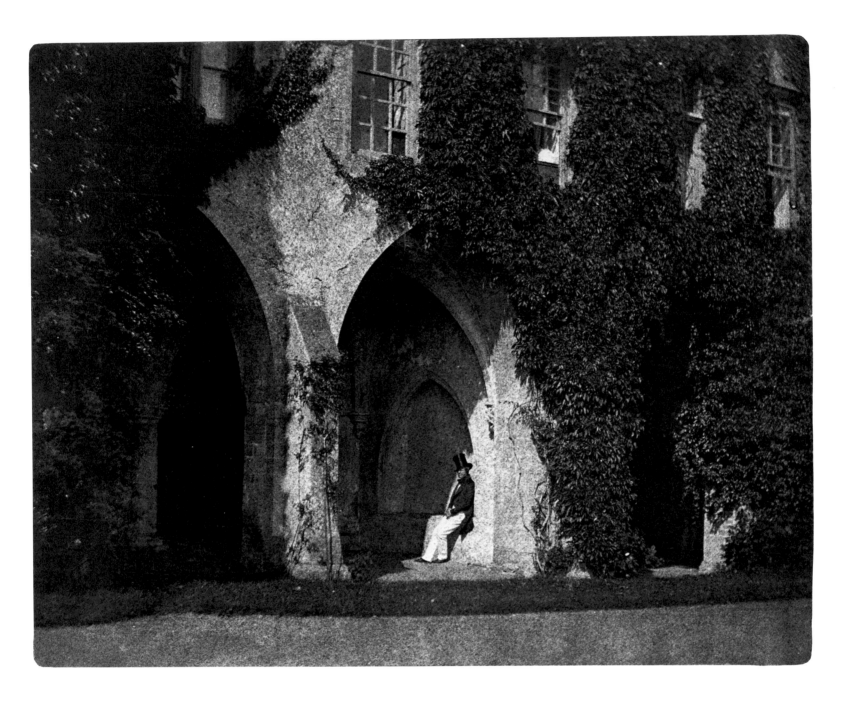

William Henry Fox Talbot, *Cloisters of Lacock Abbey,* 1844

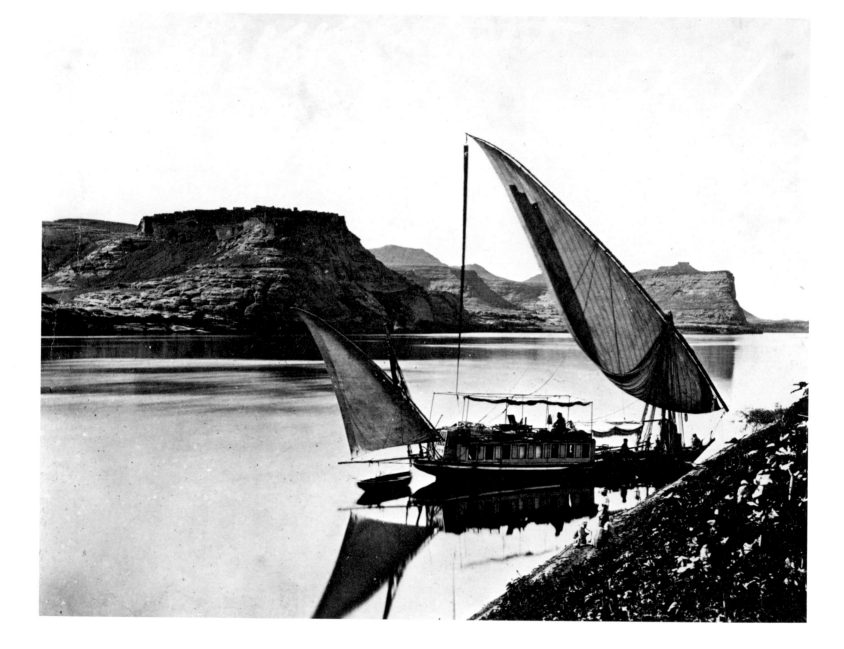

above: Francis Frith, *Travelers Boat at Ibrim*, c. 1860
opposite: David Octavius Hill and Robert Adamson,
The Reverend Robert Young, c. 1845

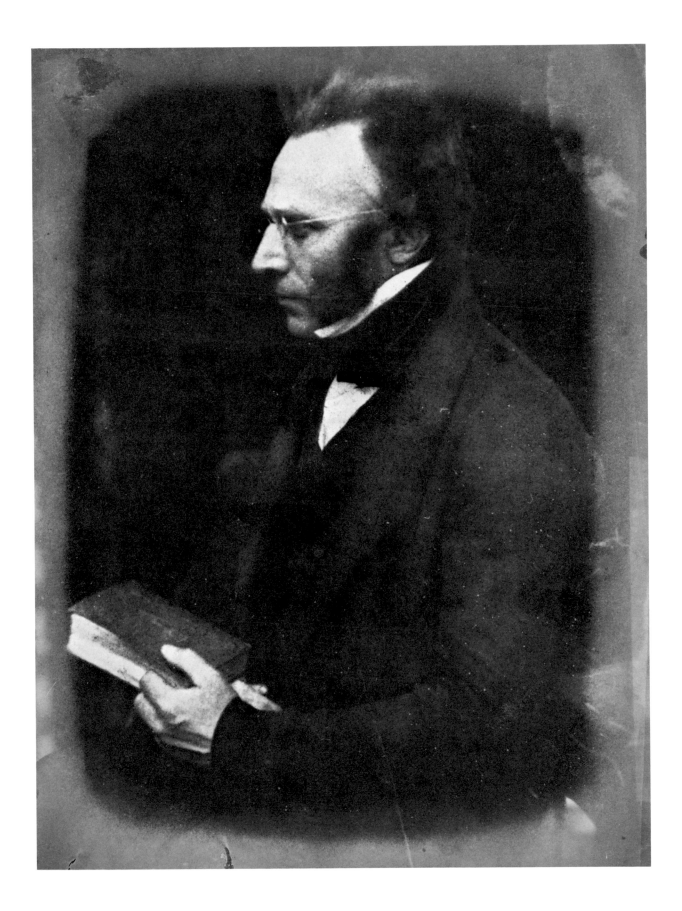

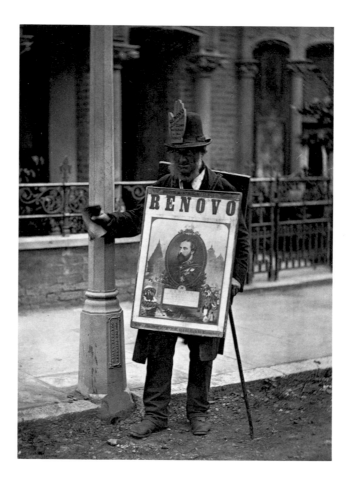

John Thomson, *The London Boardmen,* c. 1877

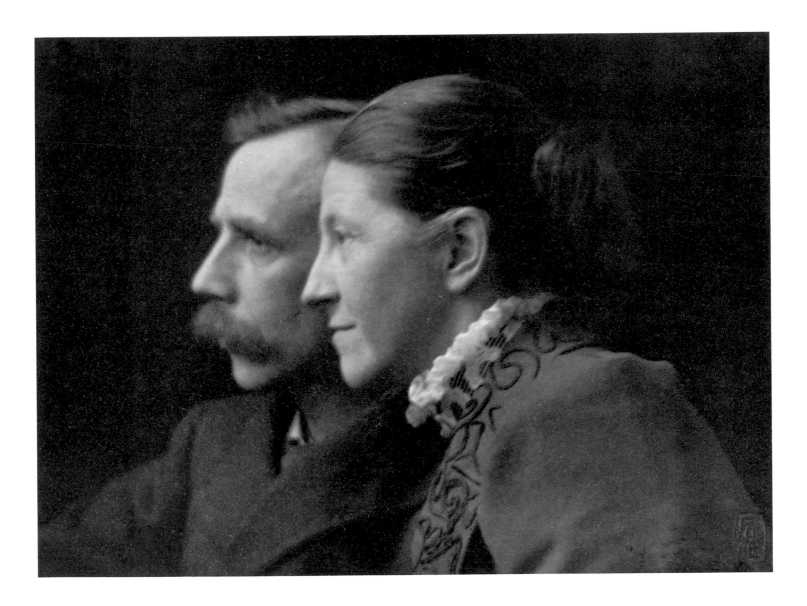

Frederick H. Evans, *Mr. and Mrs. S. Maudson Grant, Lincoln,* n.d.

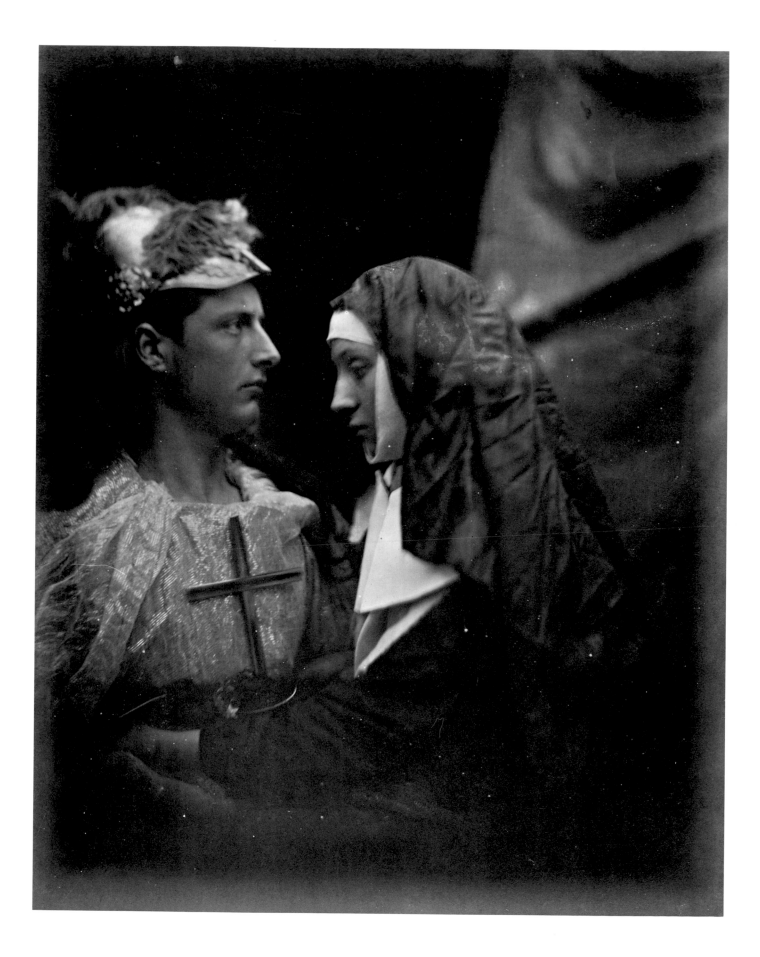

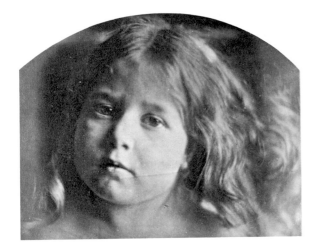

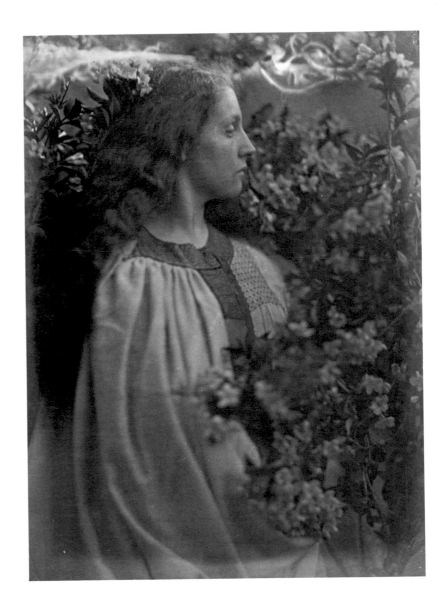

opposite: Julia Margaret Cameron, *Sir Gallahad and the Pale Nun,* c.1870

top: Julia Margaret Cameron, *Kate Keown,* 1866

bottom: Julia Margaret Cameron, *The Spirit of the Spring,* c.1870

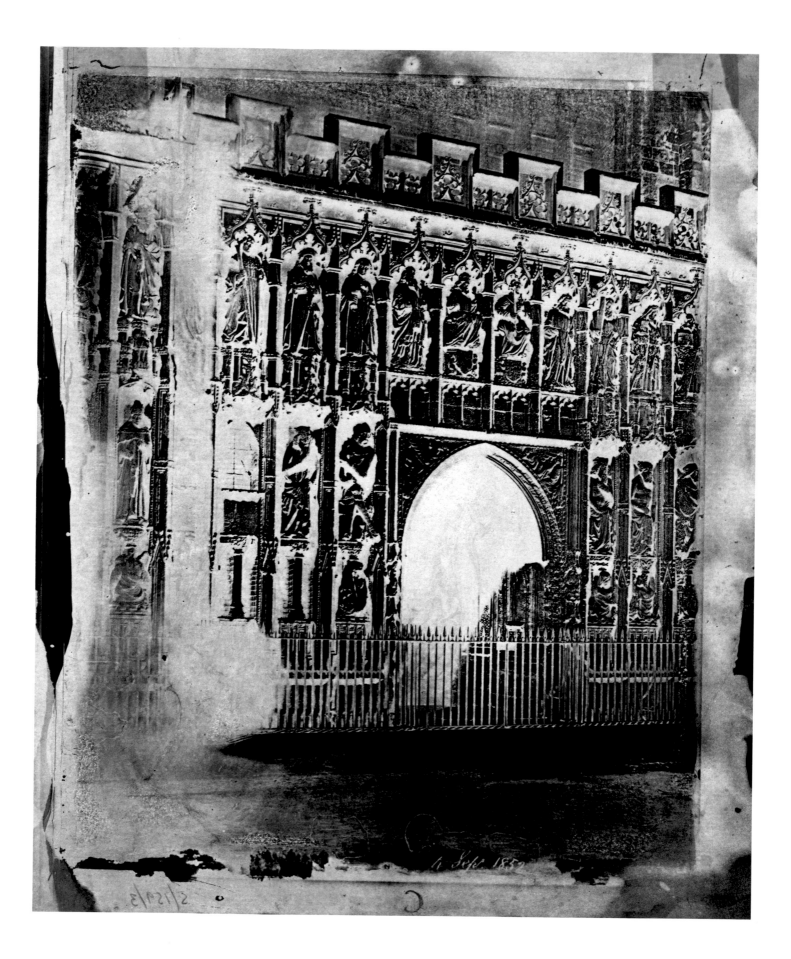

opposite: Unknown photographer, untitled, September 4, 1852
top: Eugène Pirou, *Gustave Eiffel,* c. 1880
bottom: Emile Tourtin, *Sarah Bernhardt,* 1877

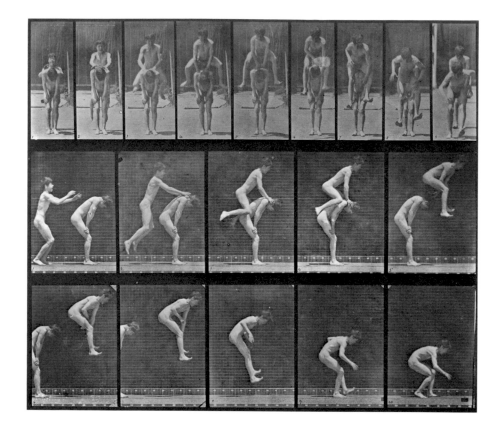

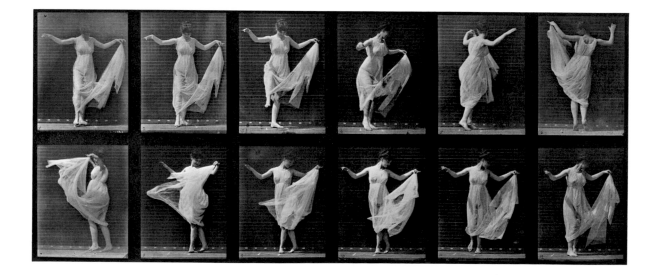

top: Eadweard Muybridge, *Animal Locomotion Plate 167*, 1887
bottom: Eadweard Muybridge, *Animal Locomotion Plate 187*, 1887

Jeremiah Gurney, untitled, c. 1852

The very invention that was born of a desire for the most detailed realism
not only discredited that realism by too quick and easy a satisfaction, but in time
stimulated art with undreamed-of revelations of form and action.

A. HYATT MAYOR, 1946

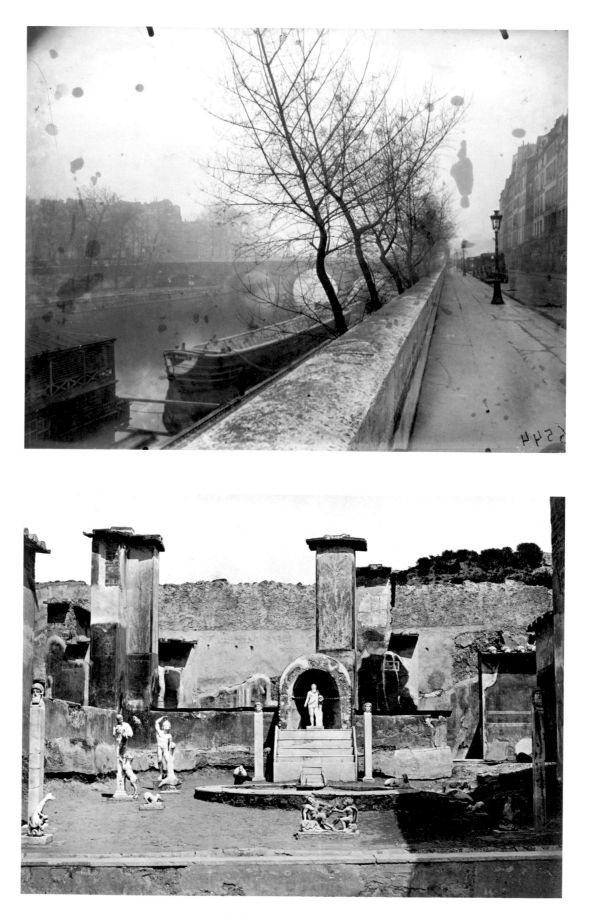

top: Jean-Eugène-Auguste Atget, untitled, 1925
bottom: Giorgio Sommer, *Casa di Marco Luerezio, Pompei,* c.1860

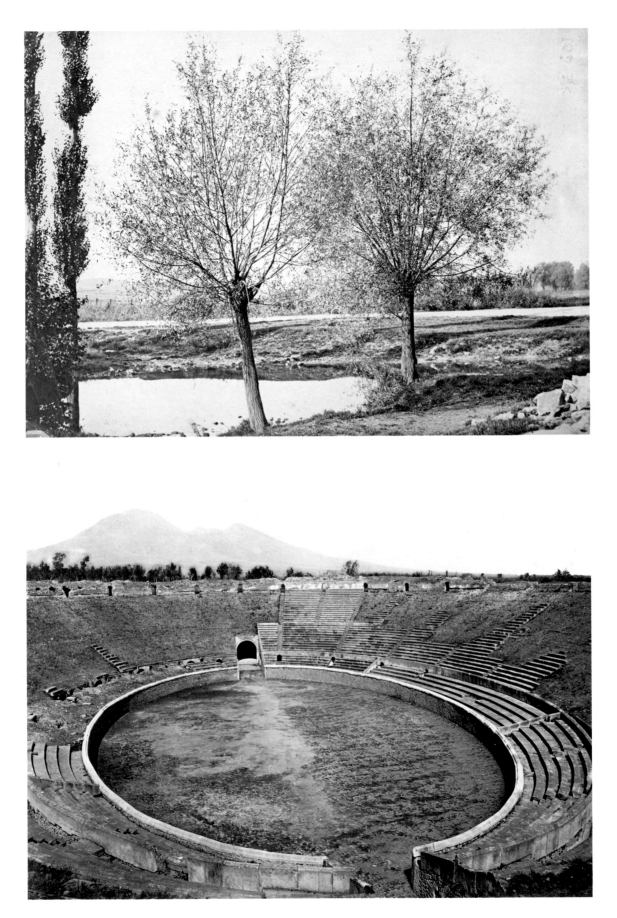

top: Unknown photographer, n.d.
bottom: Giorgio Sommer, *Anfiteatro, Pompei,* c. 1860

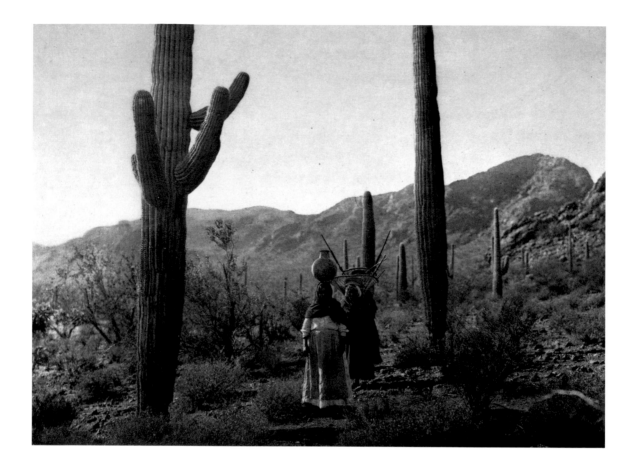

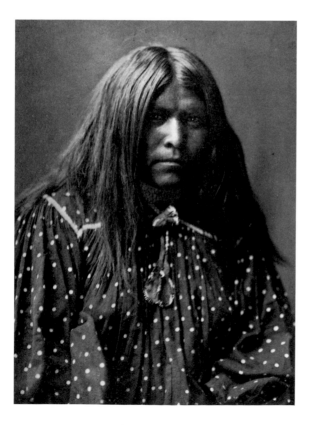

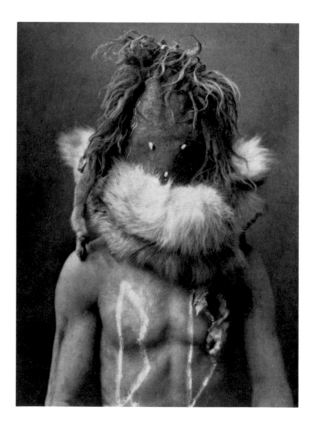

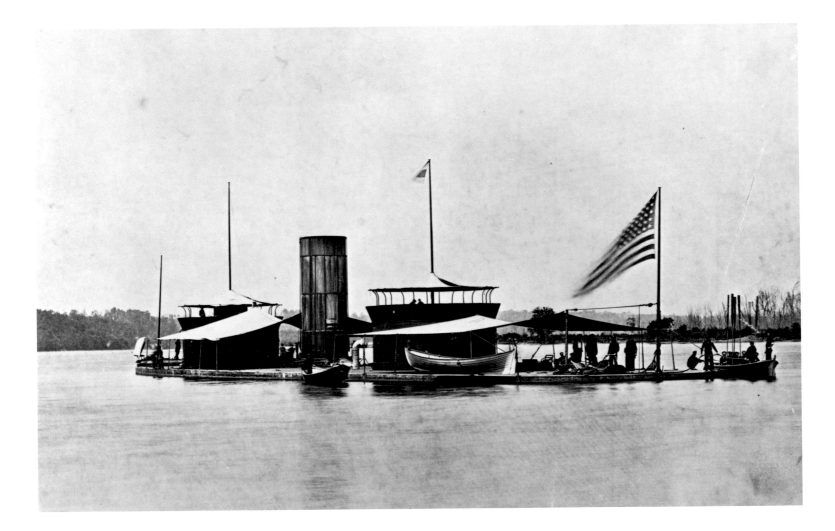

opposite, top: Edward S. Curtis, *Hasen Harvest, Oahatika,* c. 1907
left: Edward S. Curtis, *Nalin Lage, Apache,* c. 1906
right: Edward S. Curtis, *Nayenezgani, Navaho,* c. 1904
above: Unknown photographer, *The Monitor Onondaga,* n.d.

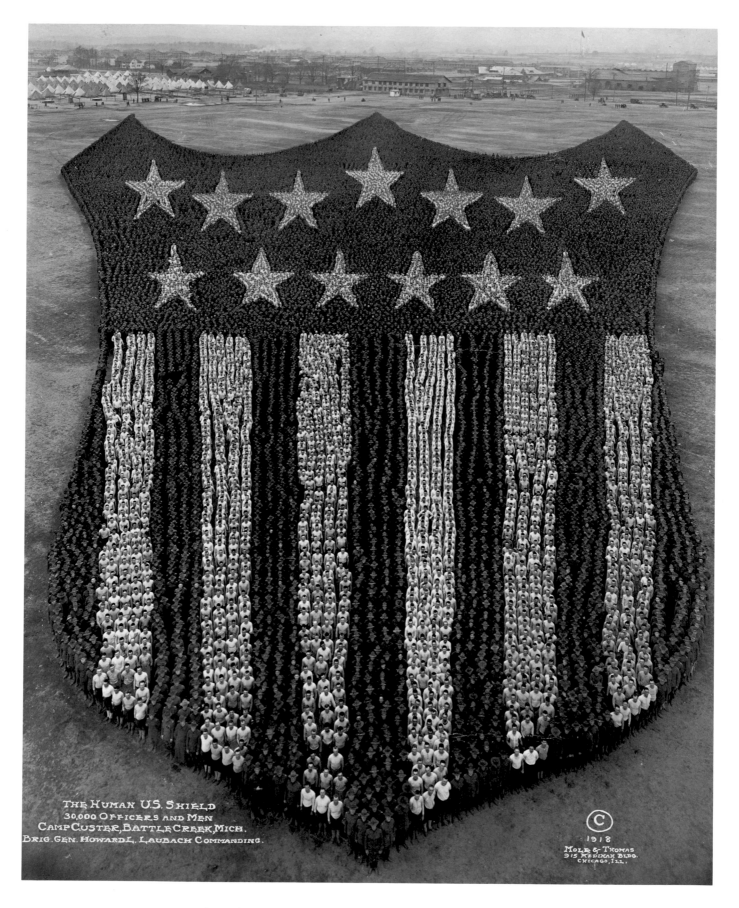

Arthur S. Mole and John D. Thomas, *The Human U.S. Shield,* 1918

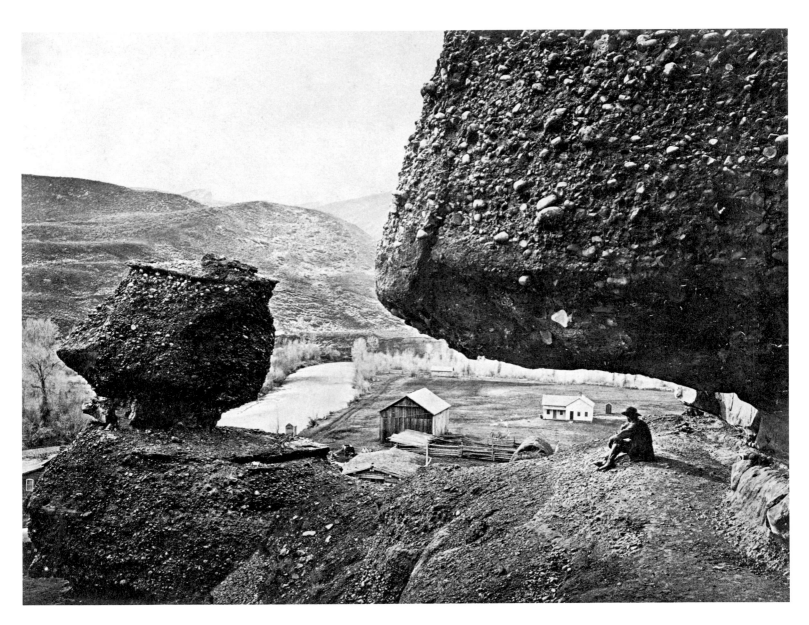

Andrew Joseph Russell, *Hanging Rock, Echo Canyon,* c. 1870

The eye of any age is so subtly yet inexorably a part of the mind of that age that one is tempted to wonder if photography could have been invented at any time before the 1830s in spite of the fact that the elements had been on hand for centuries. Certainly the photograph would have seemed a distraction of vicious curiosity to the mediaeval scrutiny of everything for possible symbolism and moral value.

A. HYATT MAYOR, 1946

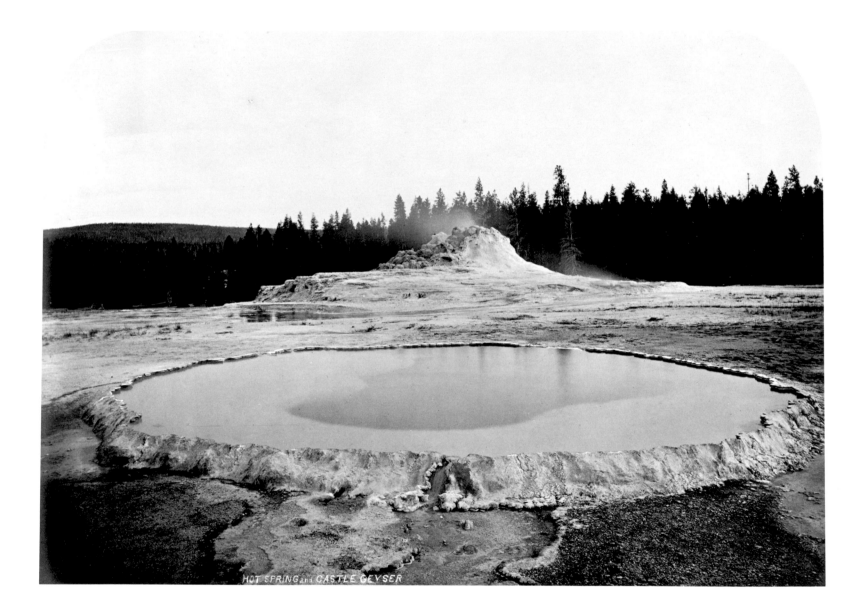

William Henry Jackson, *Hot Spring and Castle Geyser,* c. 1873

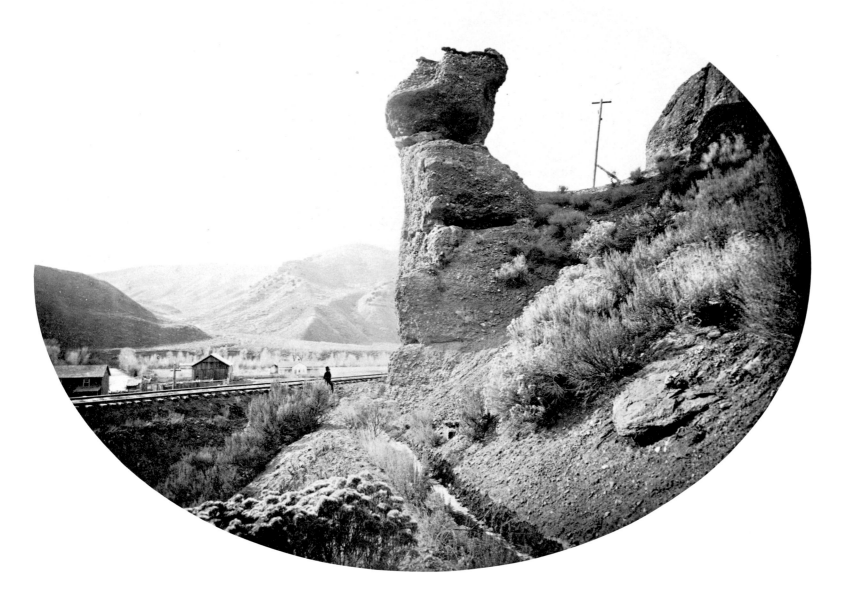

Carleton E. Watkins (attribution), [Pulpit Rock, Utah], c. 1870

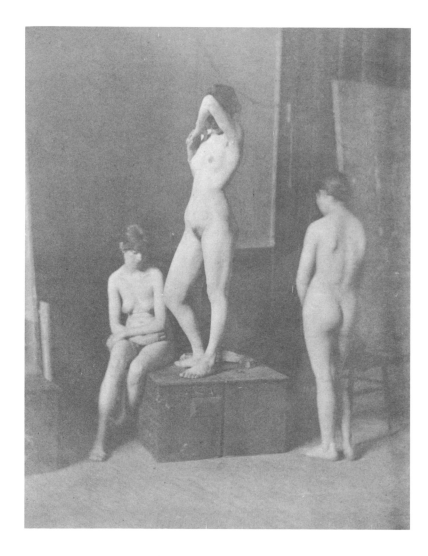

Thomas Eakins, [Pennsylvania Academy of Fine Arts], c. 1880

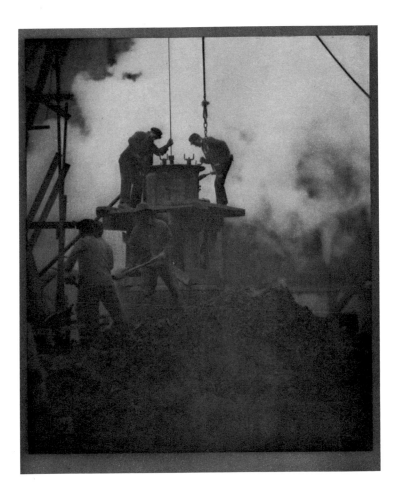

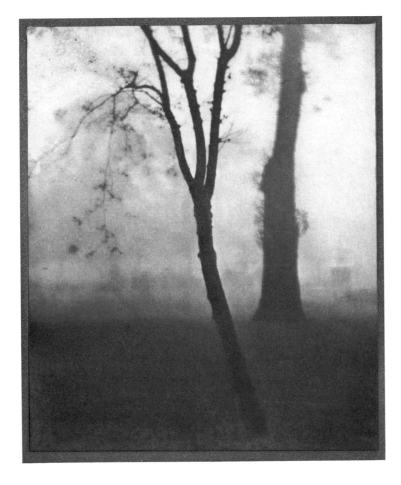

top: Alvin Langdon Coburn, *New York, The Tunnel Builders,* 1908
bottom: Alvin Langdon Coburn, *Kensington Gardens,* n.d.

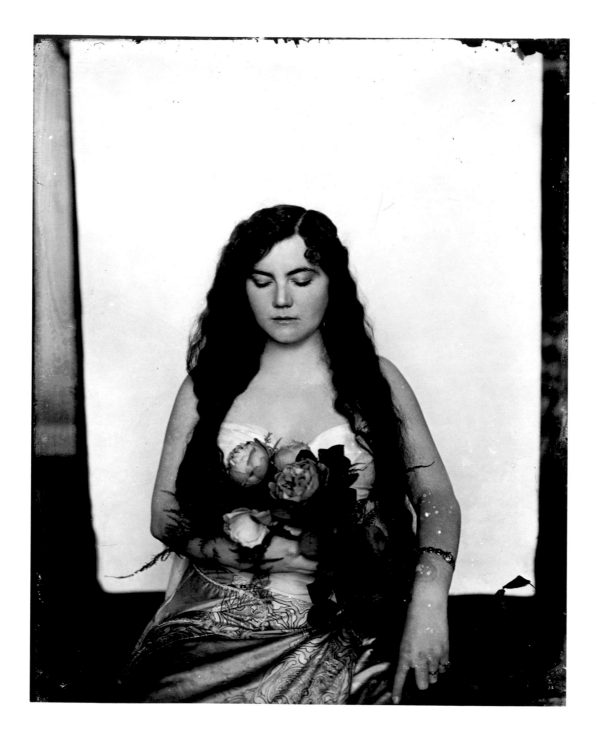

E. J. Bellocq, untitled, c. 1912

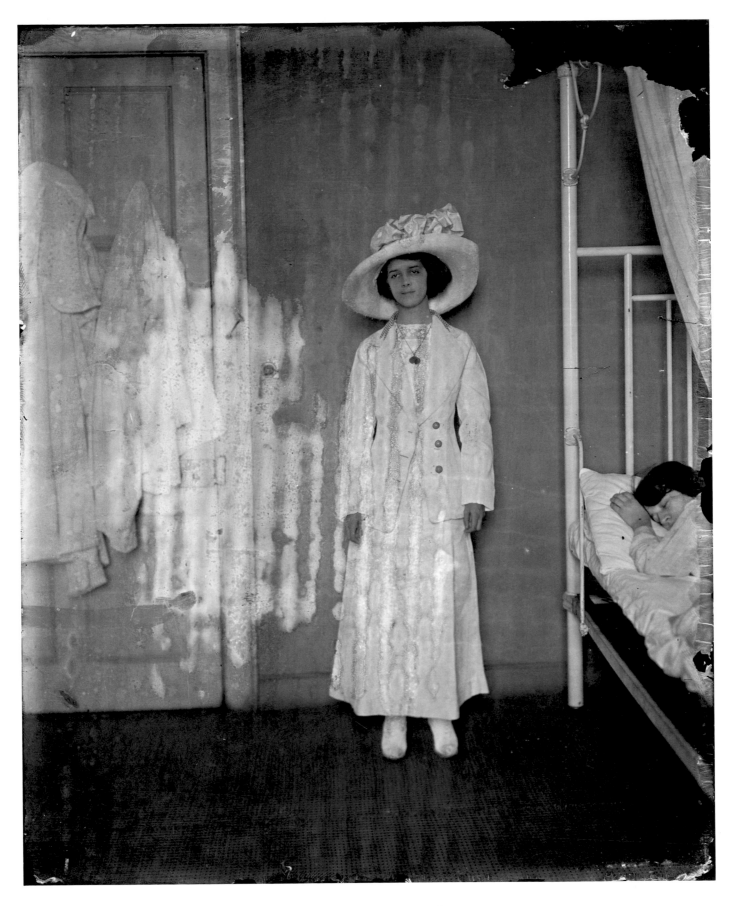

E. J. Bellocq, untitled, c. 1912

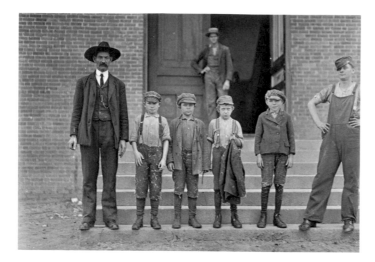

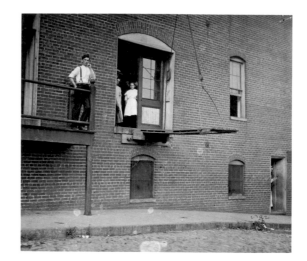

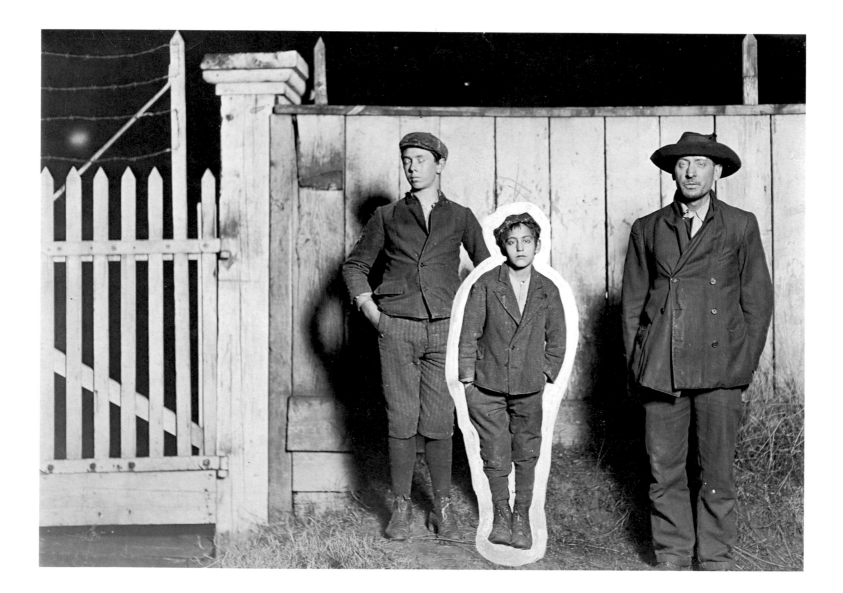

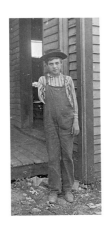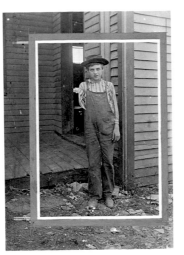

opposite, top left: Lewis W. Hine, [factory workers, Virginia], 1911
top right: Lewis W. Hine, [factory workers, North Carolina], 1908
bottom: Lewis W. Hine, [Macon, Georgia], 1909

left: Lewis W. Hine, [boy with one arm], 1907
bottom: Lewis W. Hine, [messenger boy, Waco, Texas], 1913

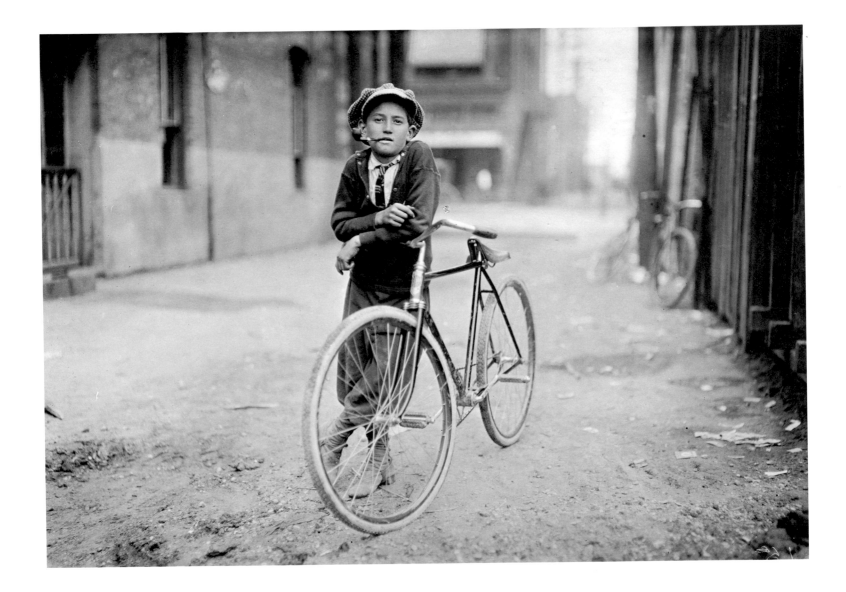

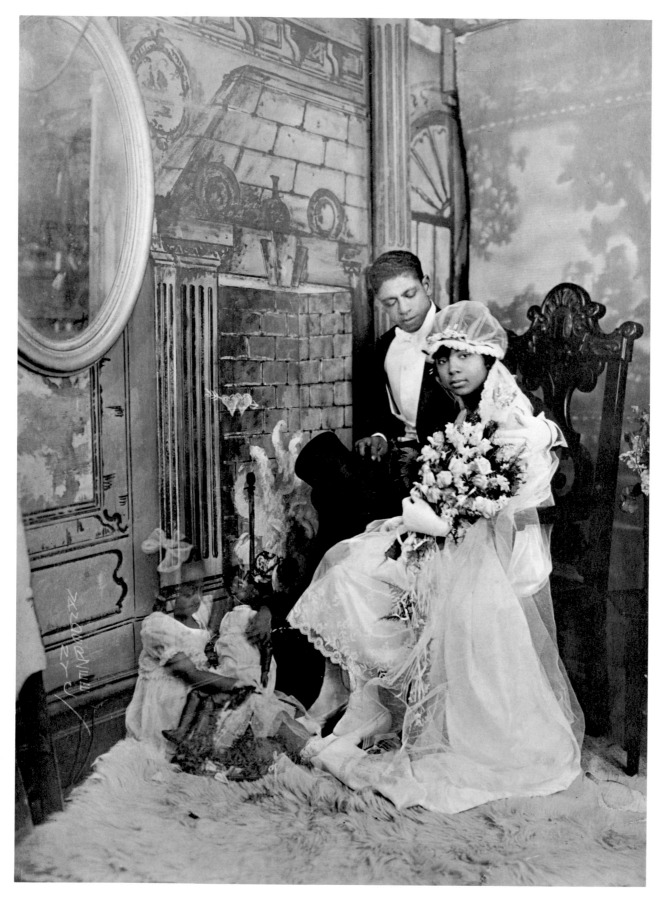

James Van DerZee, *Wedding Day, Harlem,* 1926

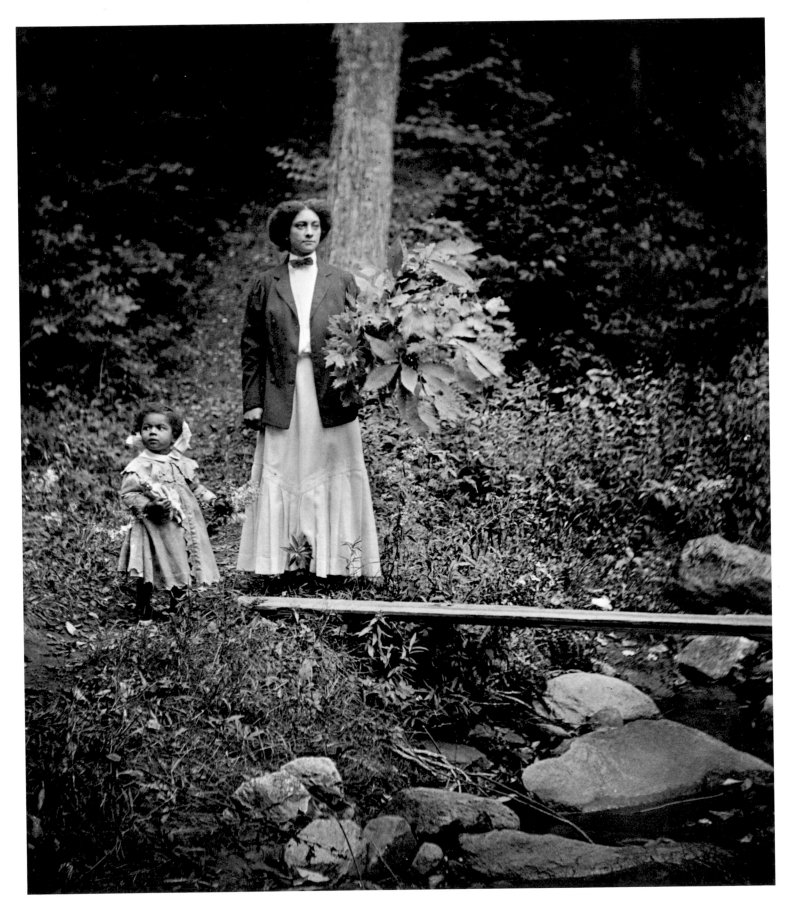

James Van DerZee, *Kate and Rachel Van DerZee, Lenox, Massachusetts,* 1909

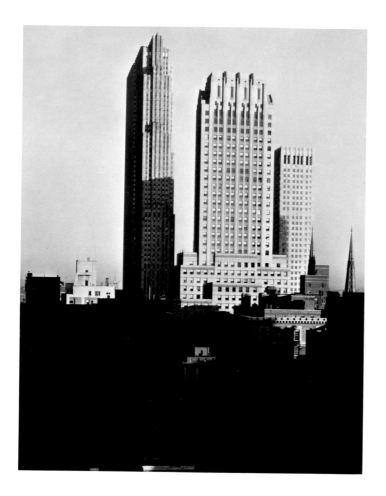

The subjects do not make the photographs.
The vision of the photographer himself
makes the subject.

FORBES WATSON, 1925

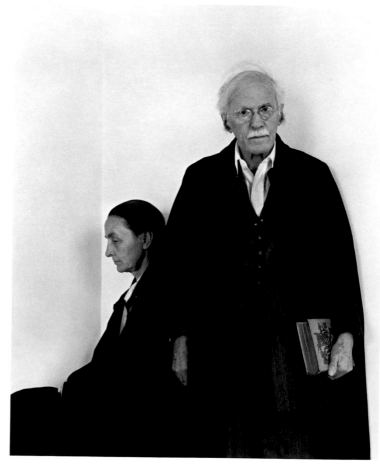

© Arnold Newman

top: Alfred Stieglitz, *From the Shelton, West,* 1935

bottom: Arnold Newman, *Stieglitz and O'Keeffe,
An American Place,* 1944

opposite: Imogen Cunningham, *Alfred Stieglitz at
An American Place,* 1934

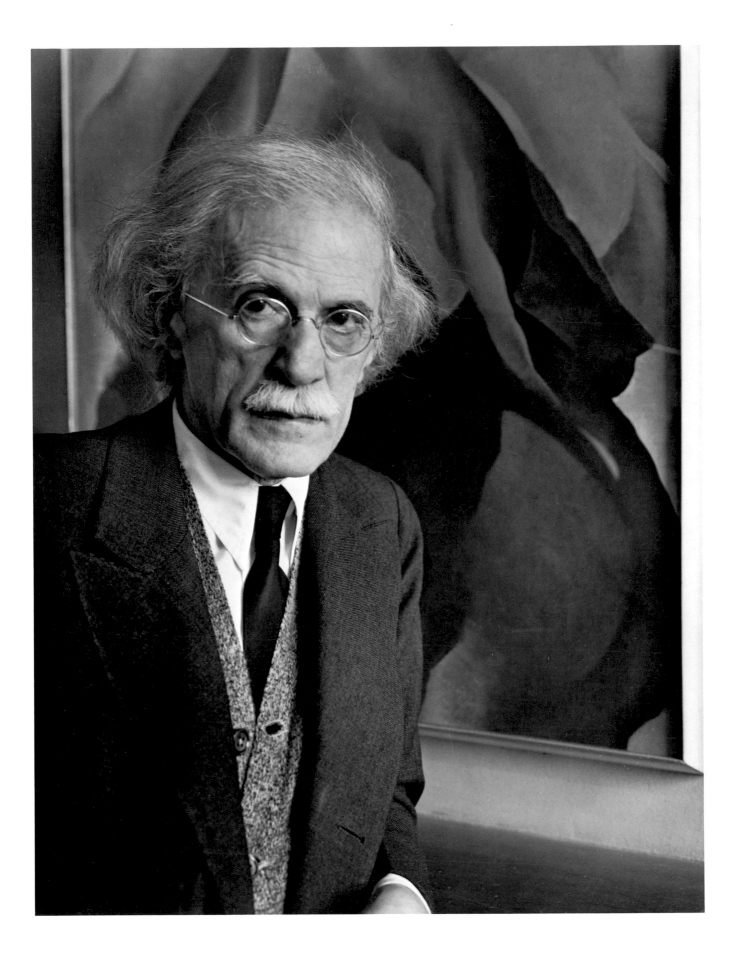

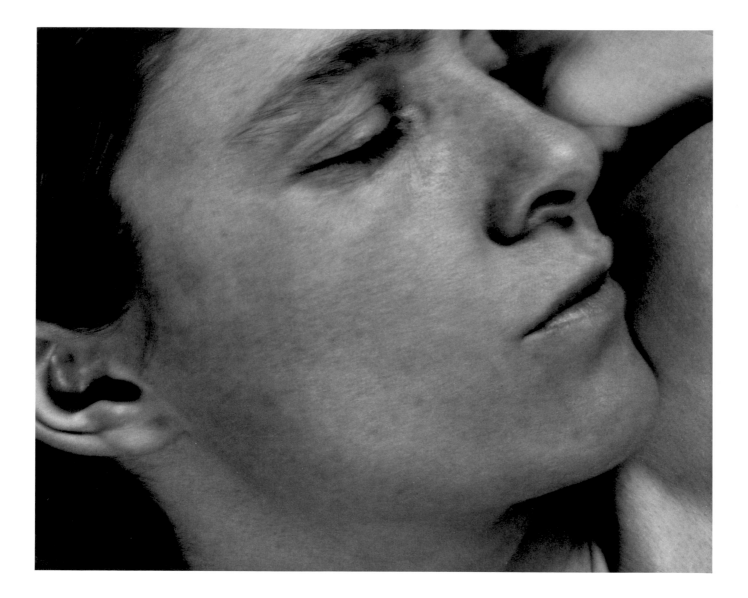

above: Paul Strand, *Rebecca Strand, New York City,* 1922
opposite: Paul Strand, *Window, Red River, New Mexico,* 1931

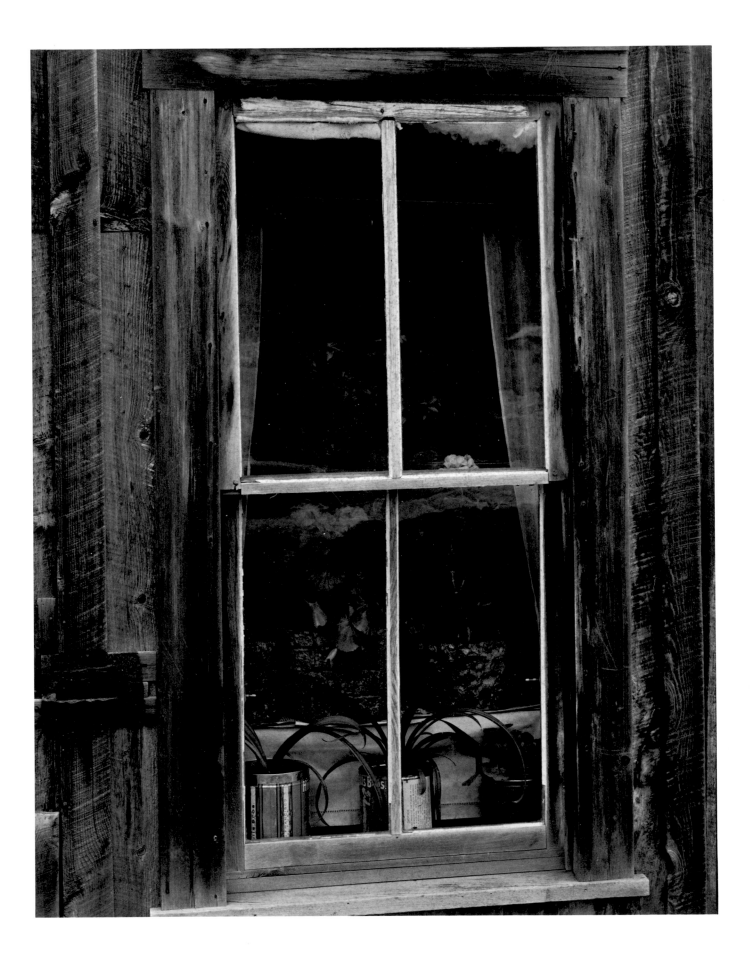

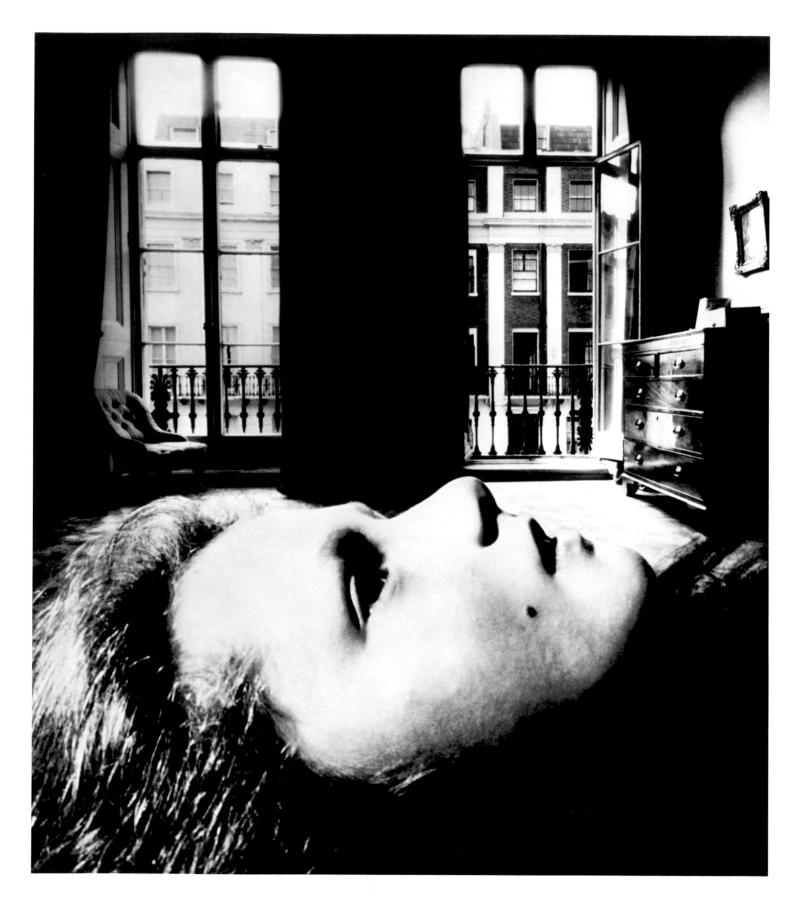

Bill Brandt, untitled, 1955

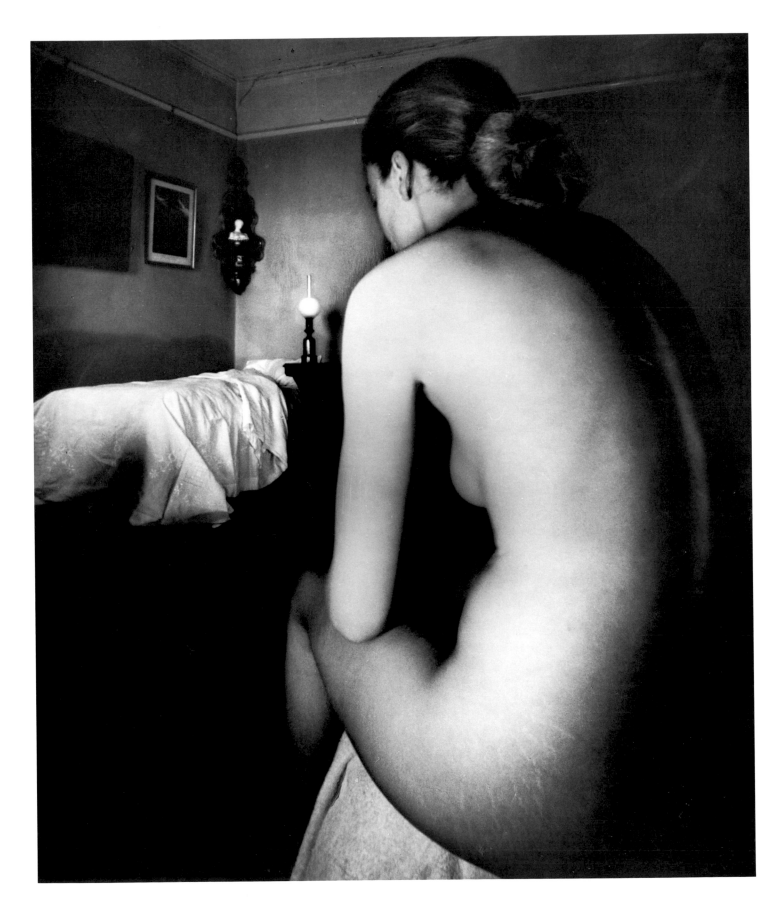

Bill Brandt, untitled, 1949

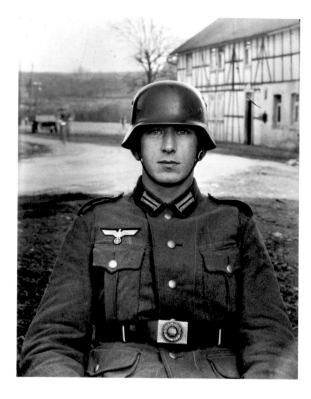

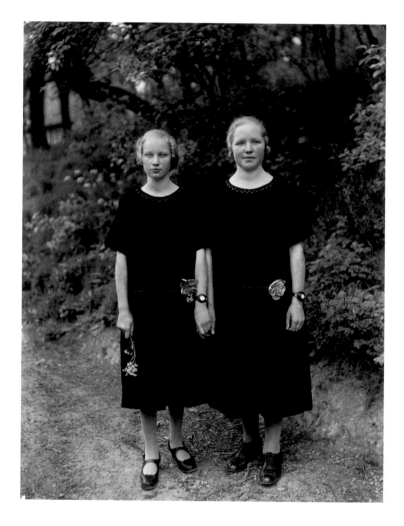

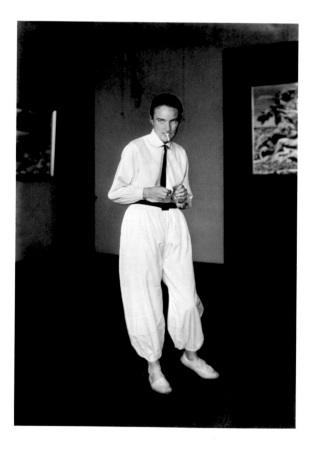

top left: August Sander, *Young Soldier, Westerwald,* 1945
lower left: August Sander, *The Wife of the Painter Peter Abelen, Cologne,* 1926
right: August Sander, *Farm Girls, Westerwald,* 1928
opposite: Val Telberg, *Fire in the Snow (The City No. 3),* c. 1948

46

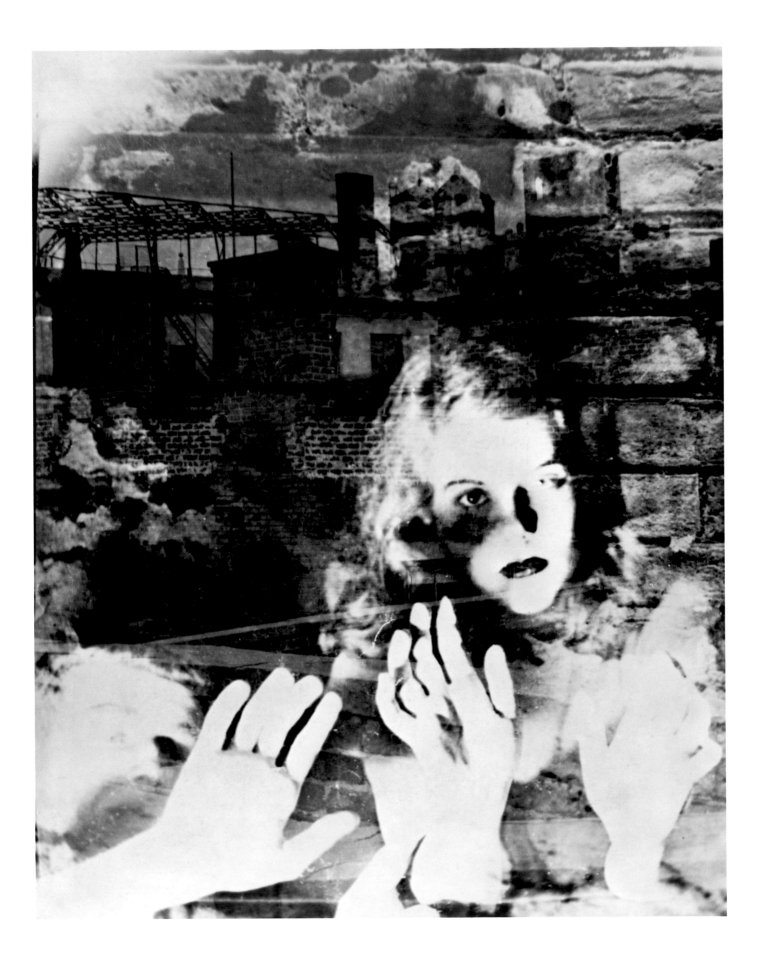

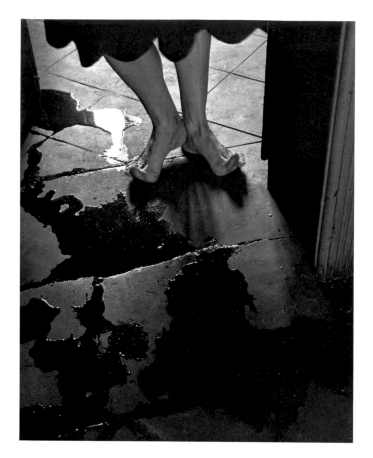

left: Manuel Alvarez Bravo, *Umbral (Threshold),* 1947
bottom: Manuel Alvarez Bravo, *Gorrión, Claro (Skylight),* 1938–40
opposite: Manuel Alvarez Bravo, *Margarita de Bonampak,* n.d.

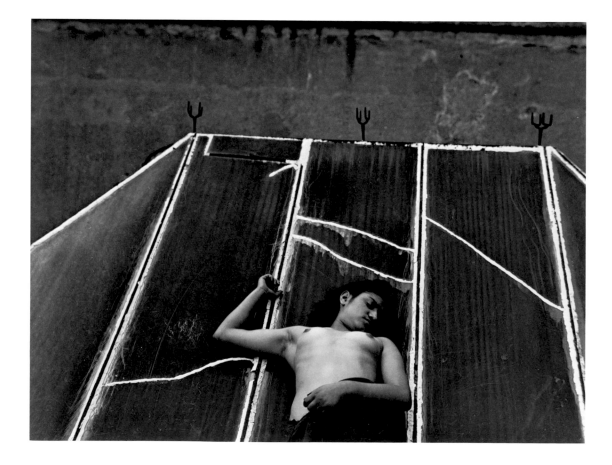

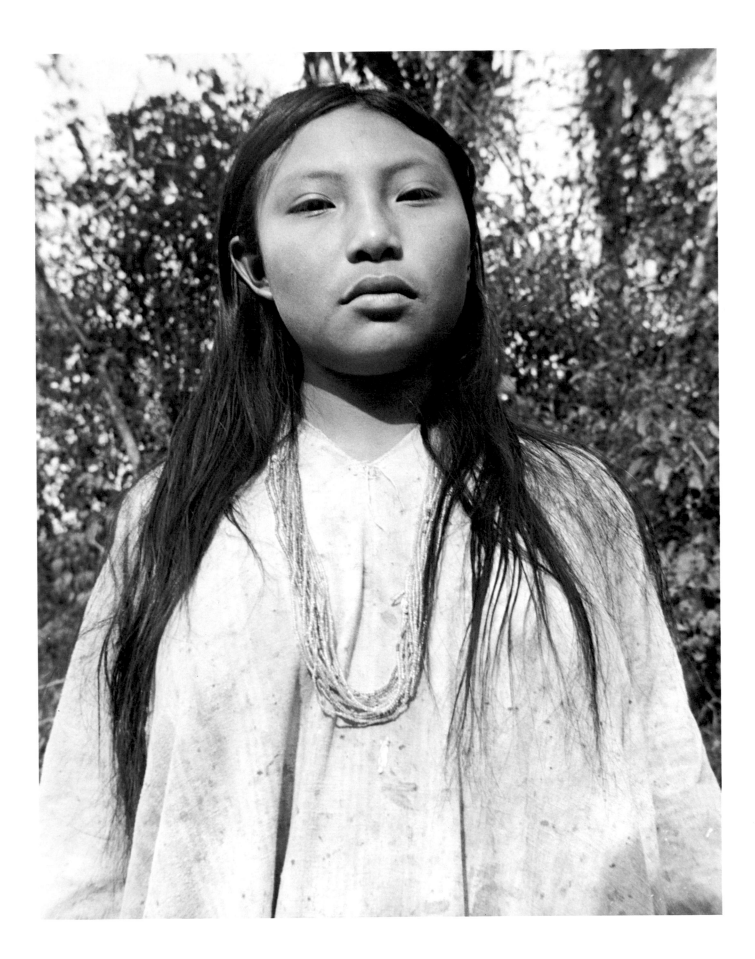

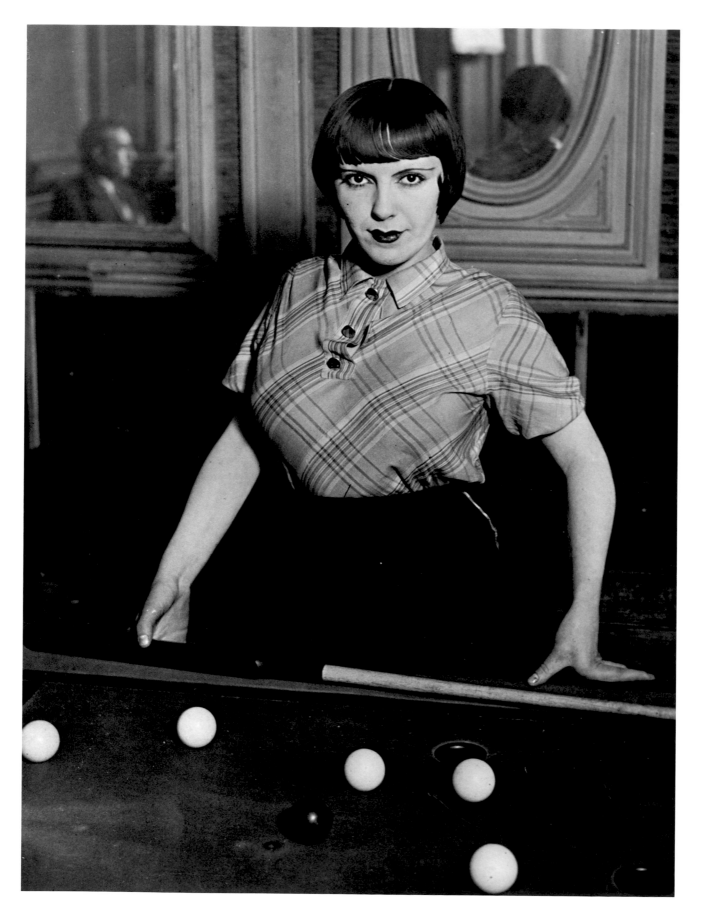

Brassaï, *La Fille au Billard Russe, Paris,* 1933

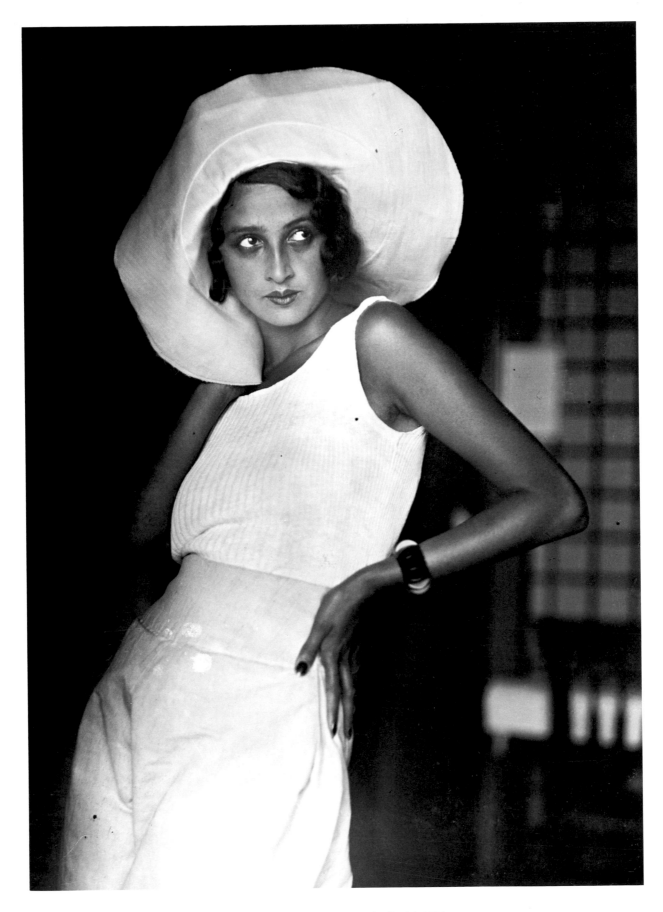

Jacques Henri Lartigue, *Renée (Perle),* 1930

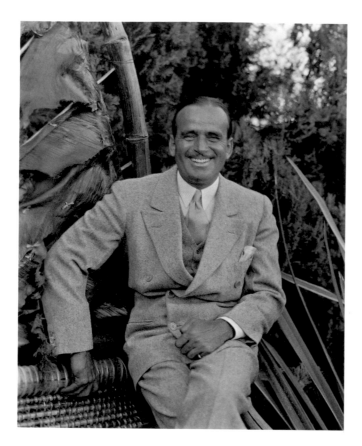

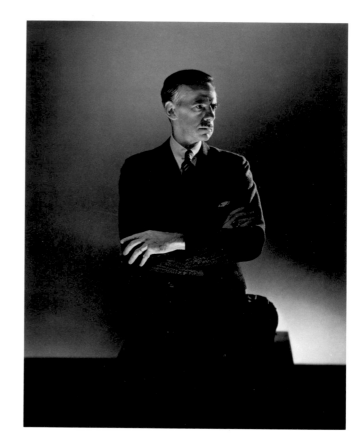

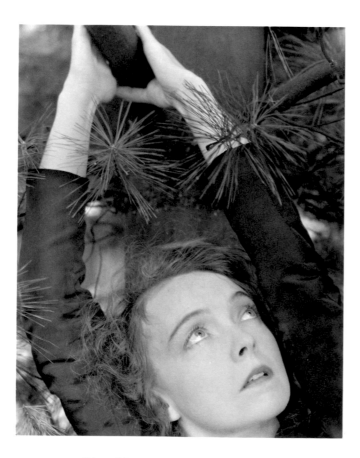

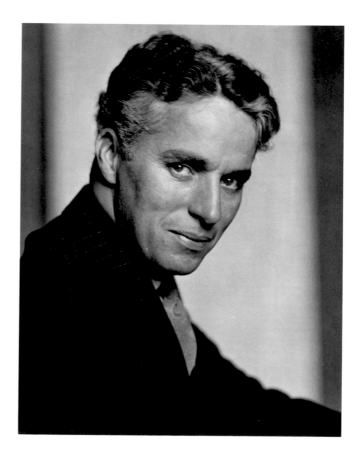

top: Edward Steichen, *Douglas Fairbanks,* c. 1928
bottom: Edward Steichen, *Lillian Gish in "Within the Gates,"* 1934

top: Edward Steichen, *Eugene O'Neill,* c. 1933
bottom: Edward Steichen, *Charlie Chaplin,* c. 1925

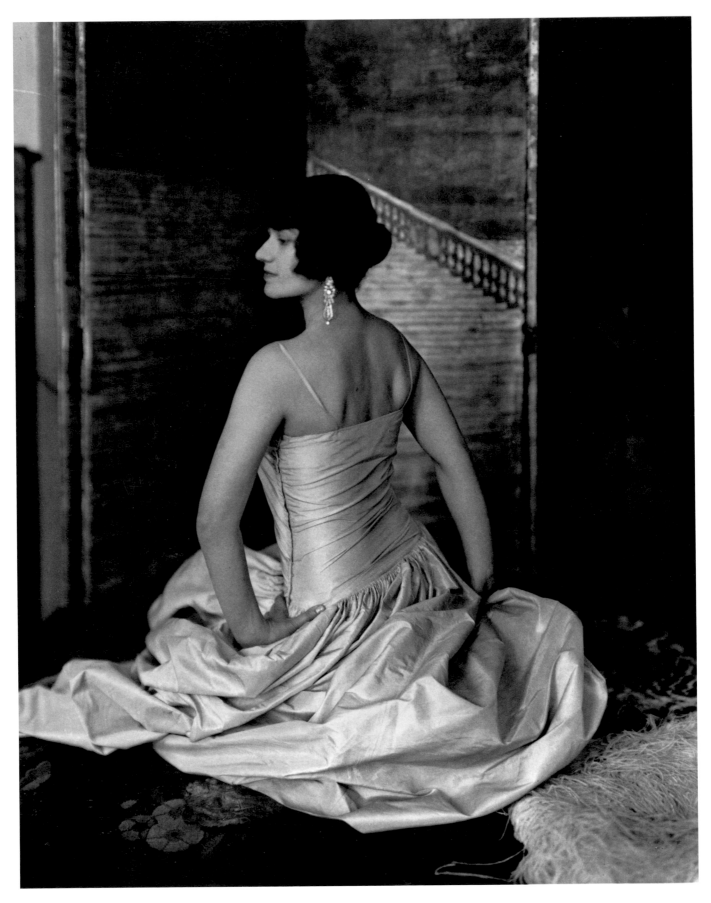

Edward Steichen, *La Duchesse de Gramont, Paris,* 1924

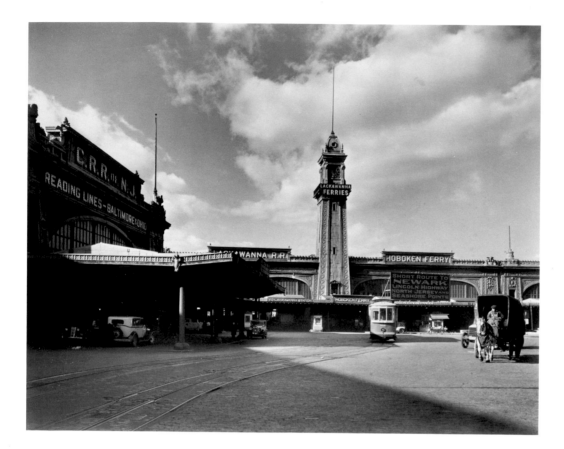

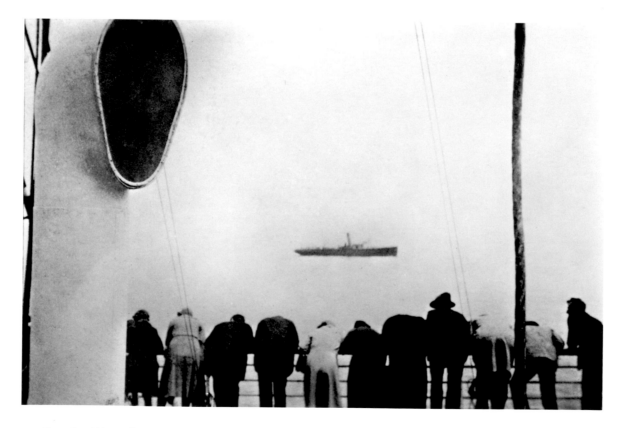

top: Berenice Abbott, *Ferry, West 23rd Street,* 1935
bottom: George Grosz, *Over the Rail,* 1932

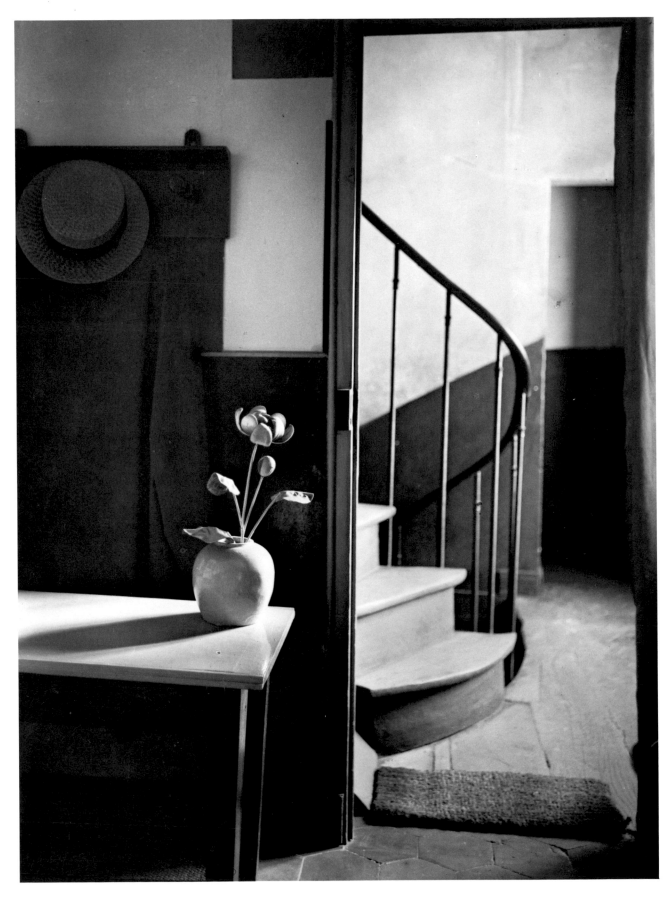

André Kertész, *Chez Mondrian, Paris,* 1926

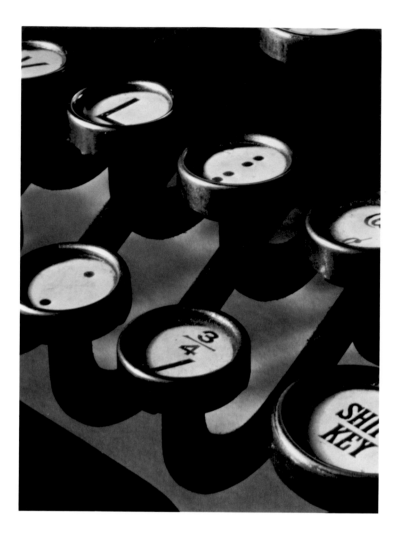

left: Ralph Steiner, *Typewriter as Design,* c. 1922
bottom: Ralph Steiner, *Lollipop,* 1922

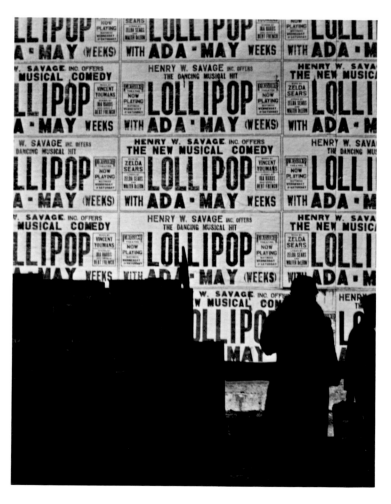

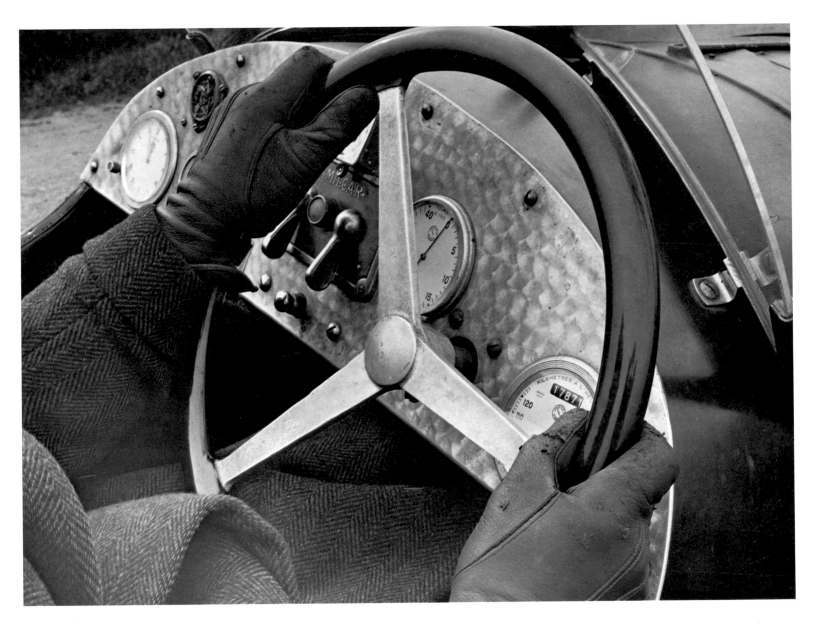

Albert Renger-Patzsch, untitled, n.d.

I'm an eye. A mechanical eye. I, the machine, show you a world the way only I can see it. I free myself for today and forever from human immobility. I'm in constant movement. I approach and pull away from objects. I creep under them. I move alongside a running horse's mouth. I fall and rise with the falling and rising bodies. This is I, the machine, maneuvering in the chaotic movements, recording one movement after another in the most complex combinations. Freed from the boundaries of time and space, I coordinate any and all points of the universe, wherever I want them to be. My way leads towards the creation of a fresh perception of the world. Thus, I explain in a new way the world unknown to you.

DZIGA VERTOV, 1923

Leaving aside the mysteries and the
inequities of human talent, brains, taste,
and reputations, the matter of art in
photography may come down to this: it is
the capture and projection of the delights of
seeing; it is the defining of observation
full and felt.

WALKER EVANS, 1969

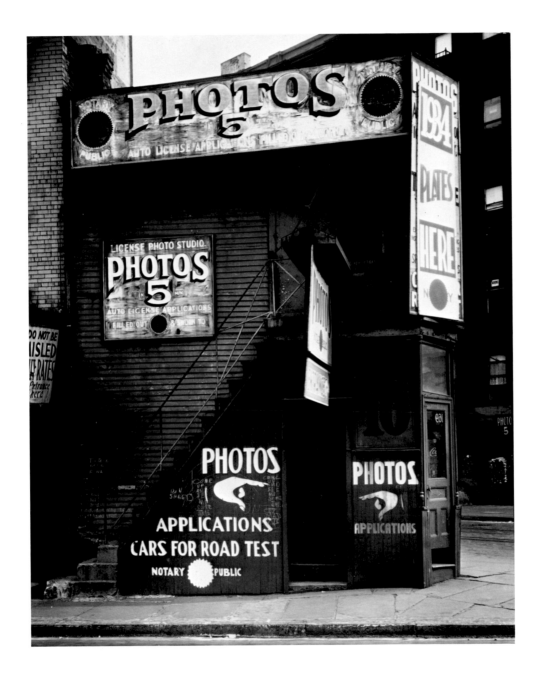

Walker Evans, *License Photo Studio, New York,* 1934

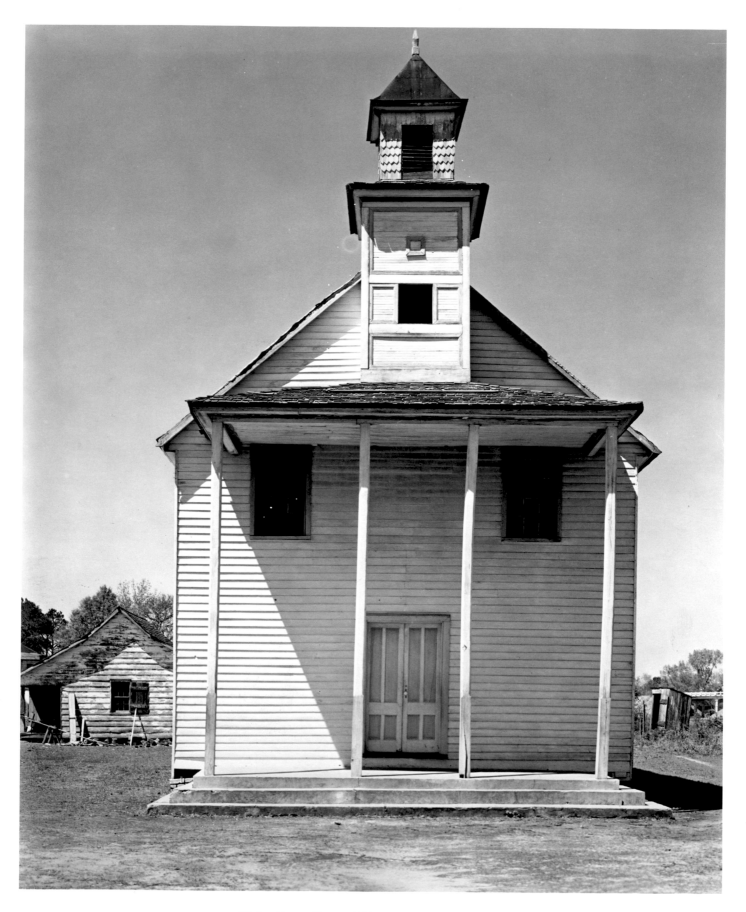

Walker Evans, *Negroes' Church, South Carolina,* 1936

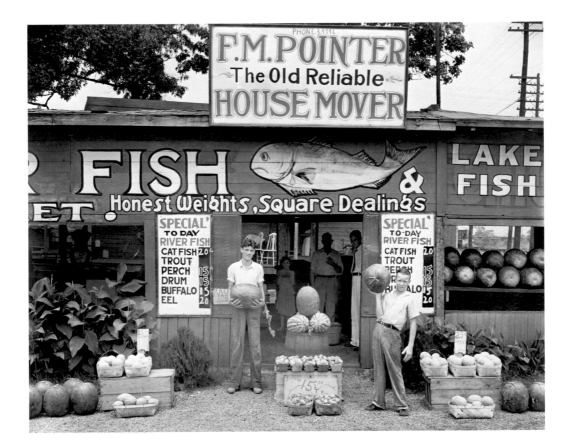

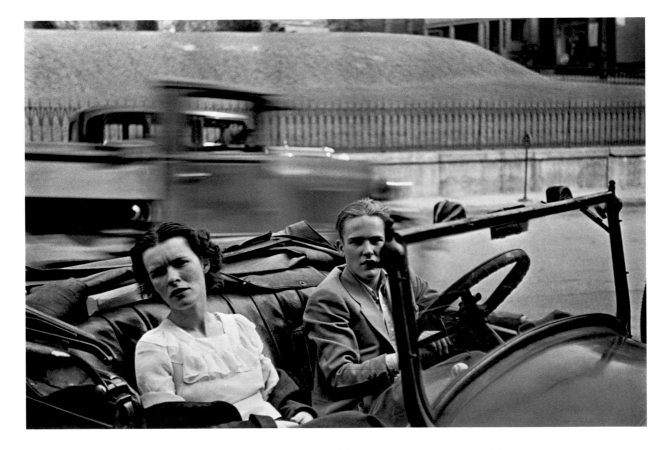

top: Walker Evans, *Roadside Stand, Vicinity Birmingham, Alabama,* 1936
bottom: Walker Evans, *Main Street, Ossining, New York,* 1932

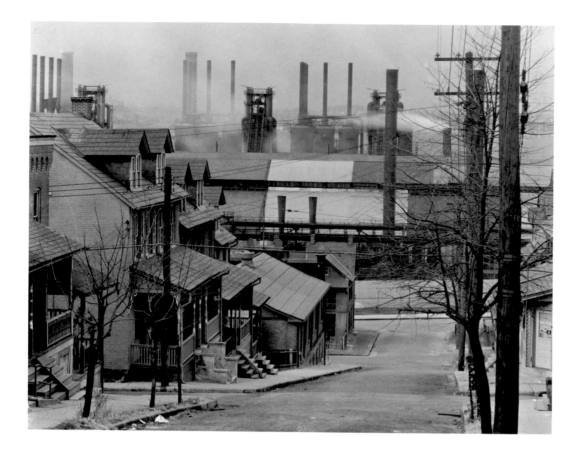

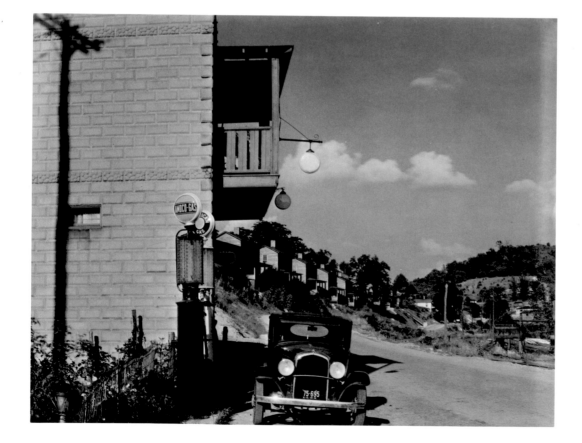

top: Walker Evans, *Houses and Steel Mill, Bethlehem, Pennsylvania,* 1935

bottom: Walker Evans, *Filling Station and Company Houses for Miners, Vicinity Morgantown, West Virginia,* 1935

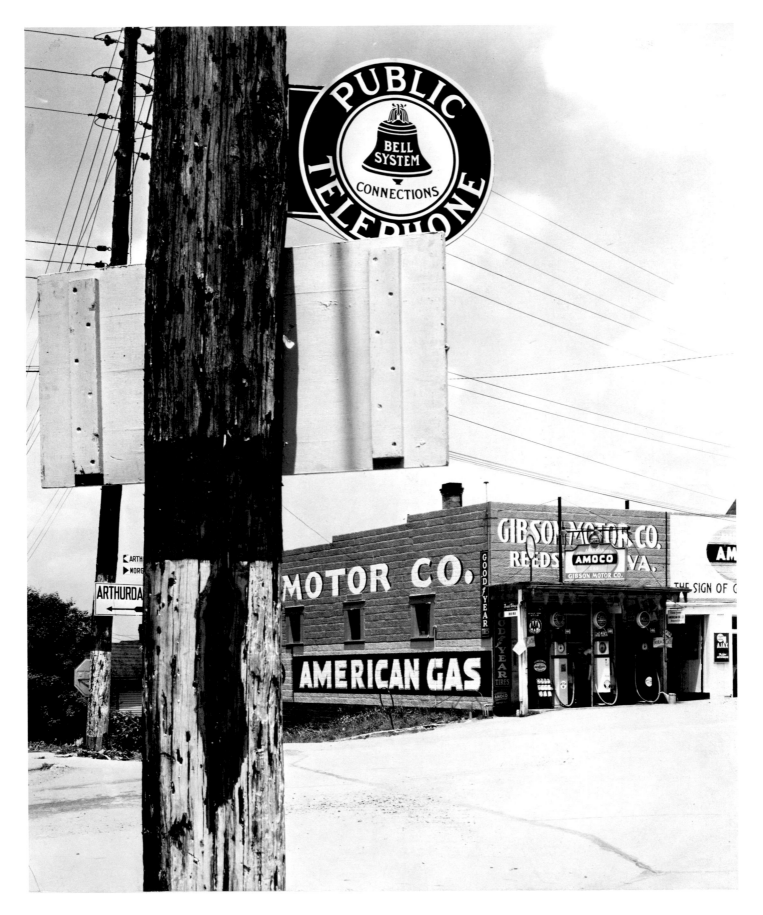

Walker Evans, *Highway Corner, Reedsville, West Virginia,* 1935

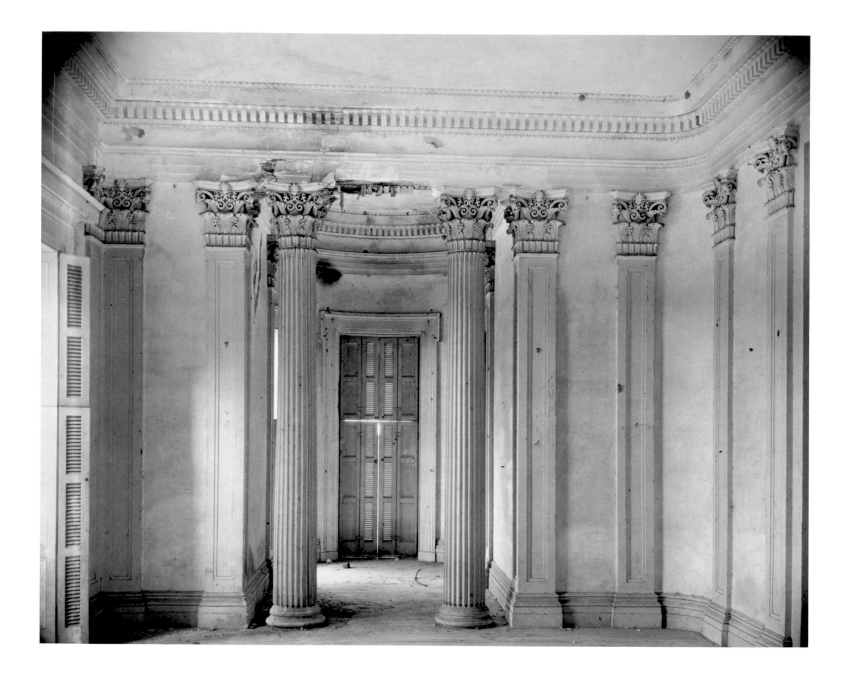

above: Walker Evans, *Breakfast Room at Belle Grove Plantation, White Chapel, Louisiana,* 1935
opposite: Clarence K. Bros, *Arlington National Cemetery,* c.1940

Modern photographers who are artists are an unusual breed. They work with the conviction, glee, pain, and daring of all artists in all time. Their belief in the power of images is limitless. The younger ones, at least, dream of making photographs like poems—reaching for tone and the spell of evocation; for resonance and panache, rhythm and glissando, no less. They intend to print serenity or shock, intensity, or the very shape of love.

WALKER EVANS, 1969

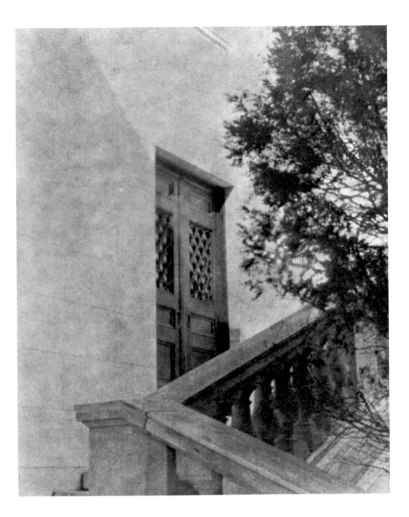

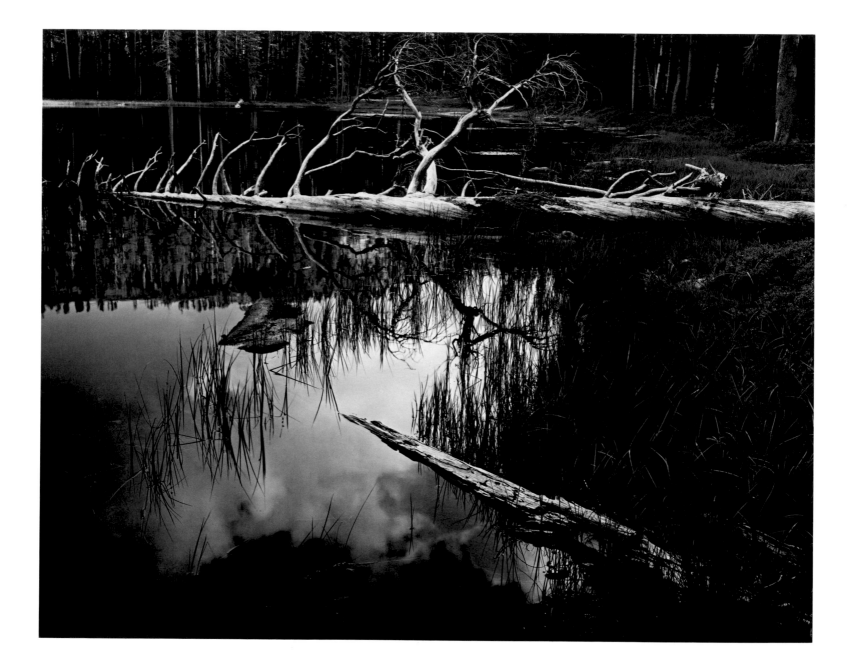

Ansel Adams, *Siesta Lake, Yosemite National Park, California,* c. 1958

Carl Chiarenza, *Somerville 9A,* 1975

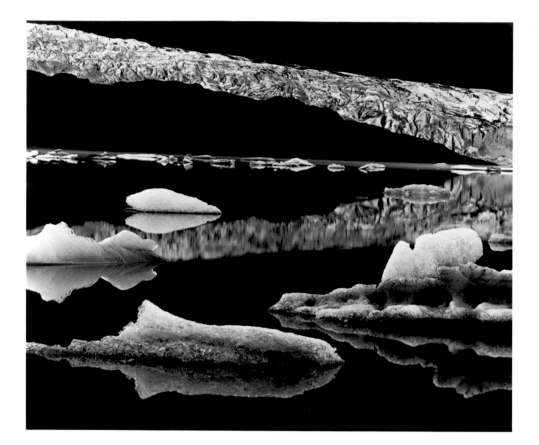

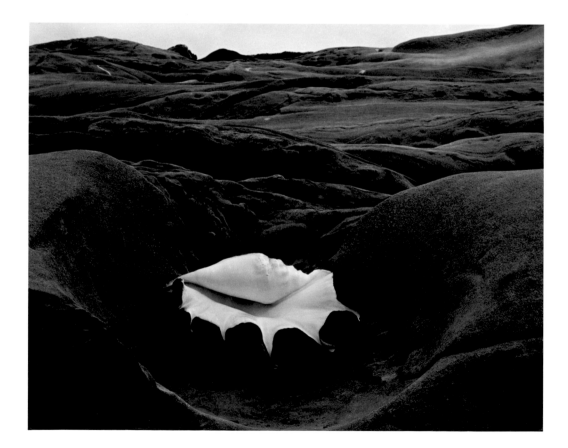

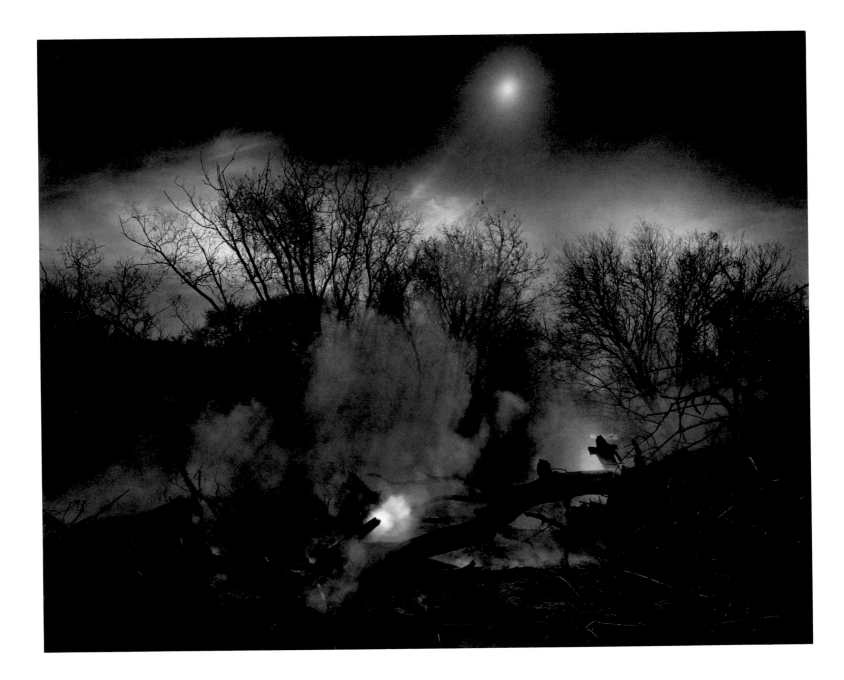

opposite, top: Brett Weston, *Mendenhall Glacier, Alaska,* 1973
bottom: Edward Weston, *Shell,* 1931
above: Wynn Bullock, *Night Scene,* 1959

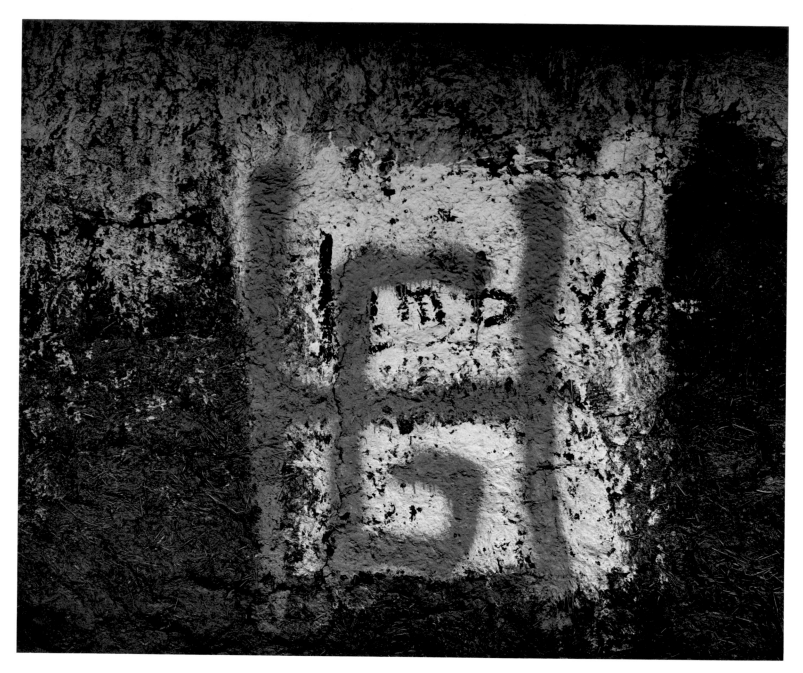

Aaron Siskind, *Mexico,* 1955

When I make a photograph I want it to be an altogether new object, complete and self-contained, whose basic condition is order—(unlike the world of events and actions whose permanent condition is change and disorder).

AARON SISKIND, 1950

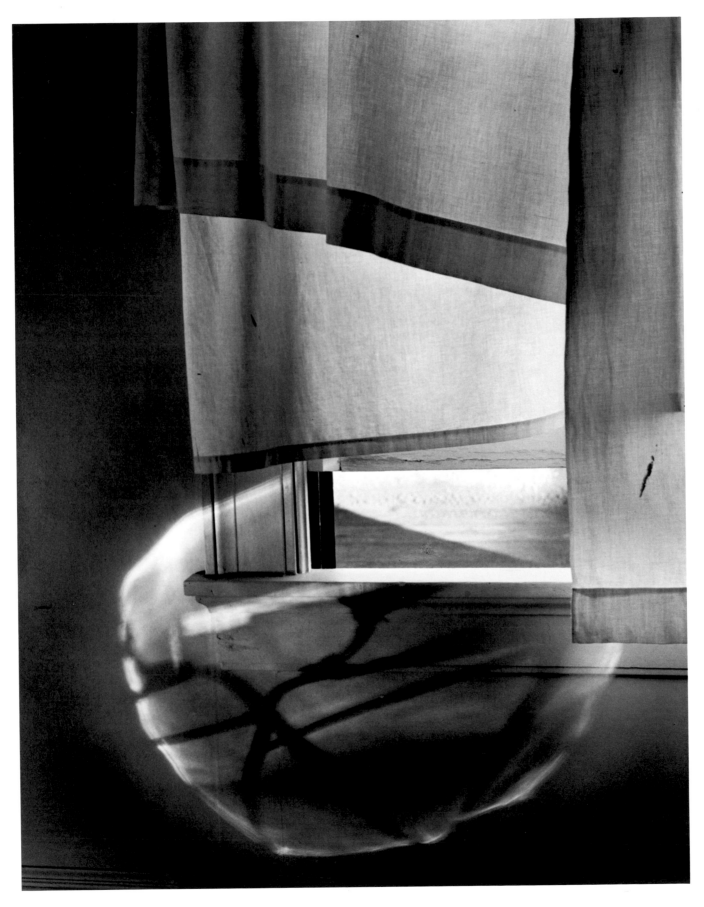

Minor White, *Windowsill Daydreaming, Rochester, New York,* 1958

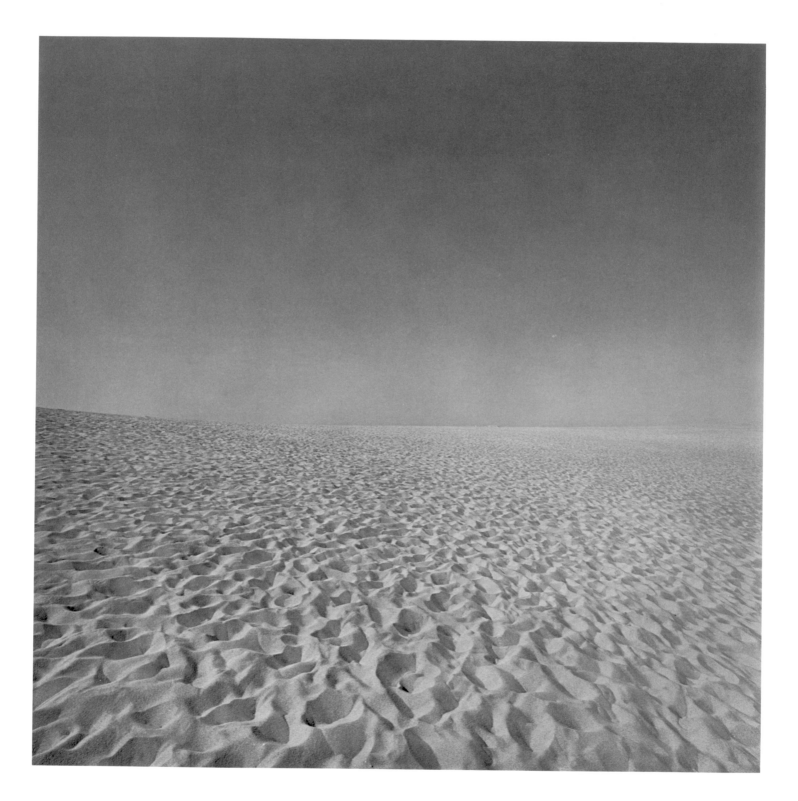

One must feel definitely, fully, before the exposure. My finished print is there on the ground glass [of the camera], with all its values, in exact proportions. The final result in my work is fixed forever with the shutter's release. Finishing, developing, and printing is no more than a careful carrying on of the image seen on the ground glass.

EDWARD WESTON, 1930

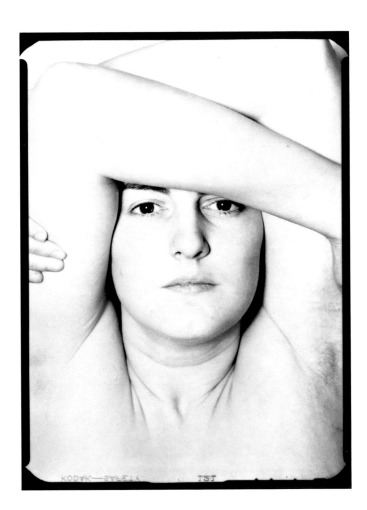

opposite: Harry Callahan, *Cape Cod,* 1972
above: Harry Callahan, *Eleanor,* c. 1947

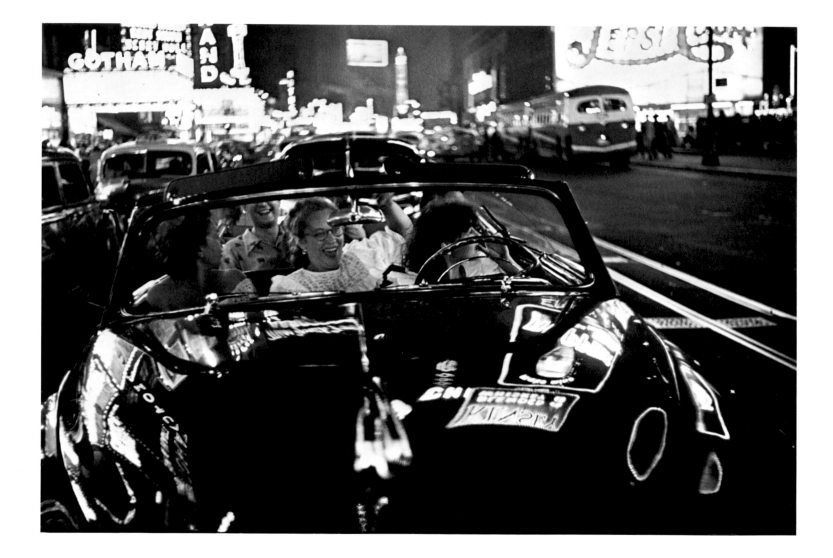

Louis Faurer, *New York City,* 1950

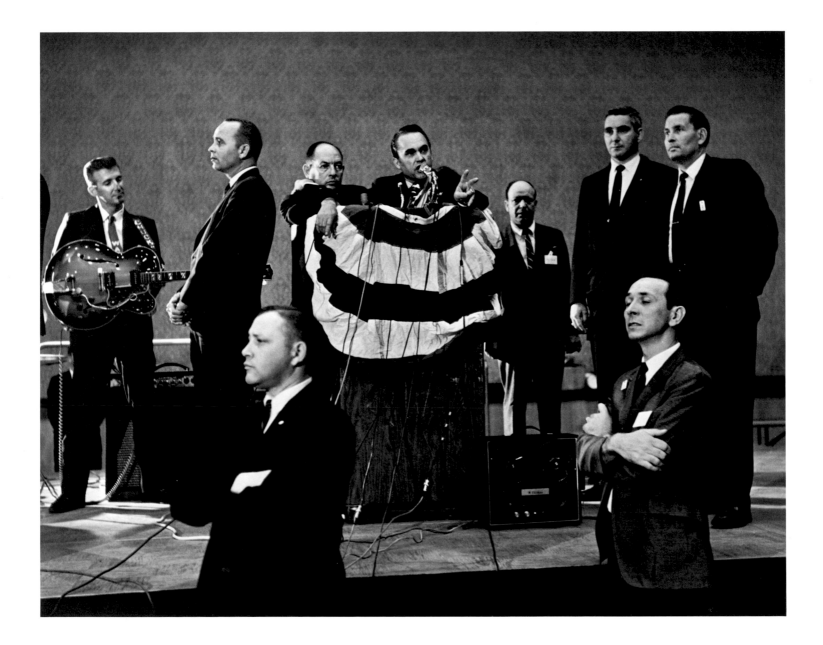

Jerome Liebling, *Governor Wallace, Minnesota,* 1968

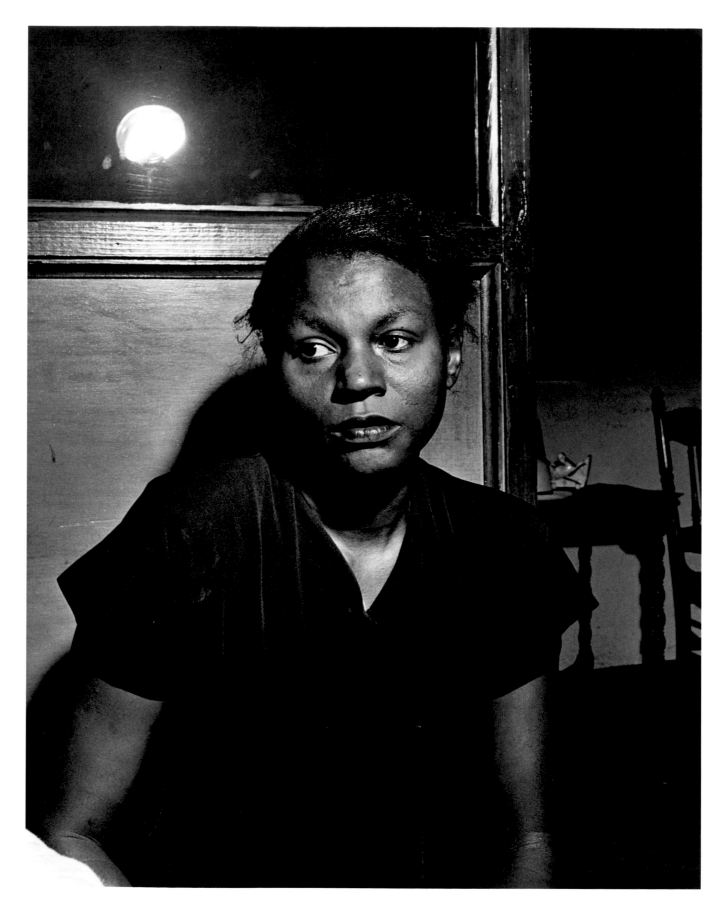

Marion Palfi, *Wife of the Lynch Victim,* 1949

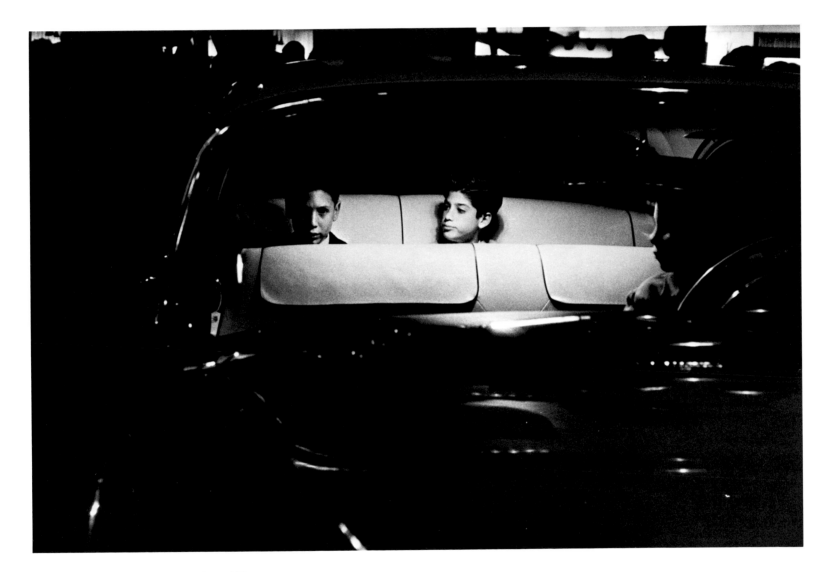

Robert Frank, *Motorama, Los Angeles,* 1956

It is always the instantaneous reaction to oneself that produces a photograph.

ROBERT FRANK, 1958

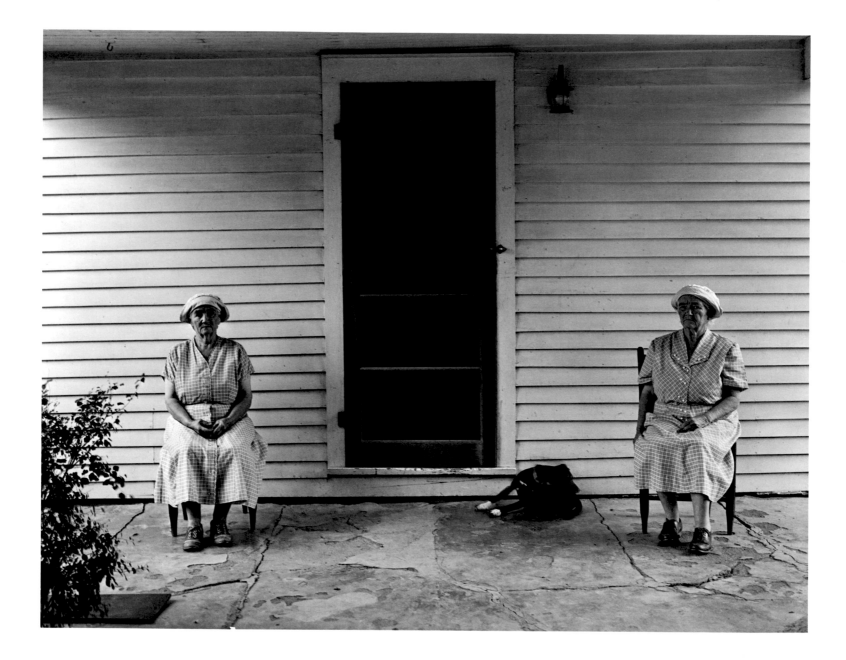

Jack Welpott, *The Farmer Twins, Stinesville, Indiana,* 1958

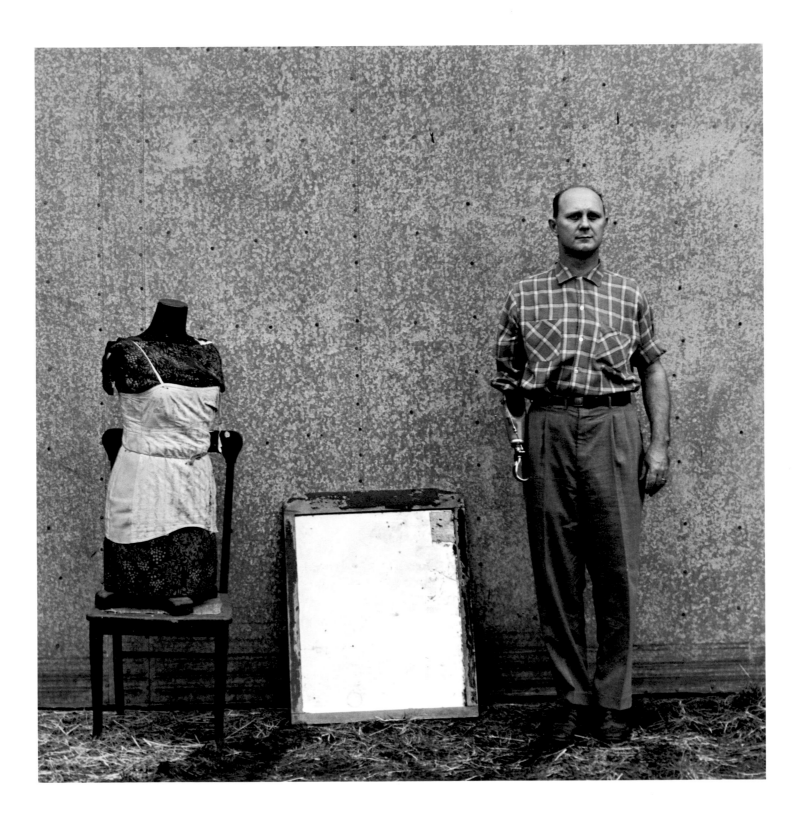

Ralph Eugene Meatyard, *Cranston Richie,* 1964

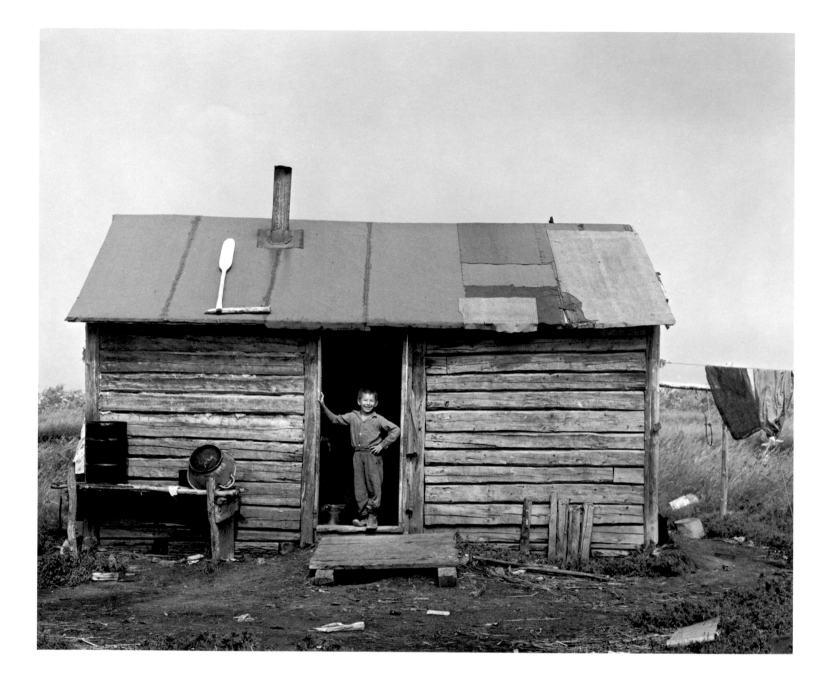

above: Robert Gene Wilcox, *Near Moosonee, Ontario, Canada,* 1963
opposite: Jerry N. Uelsmann, untitled, 1969

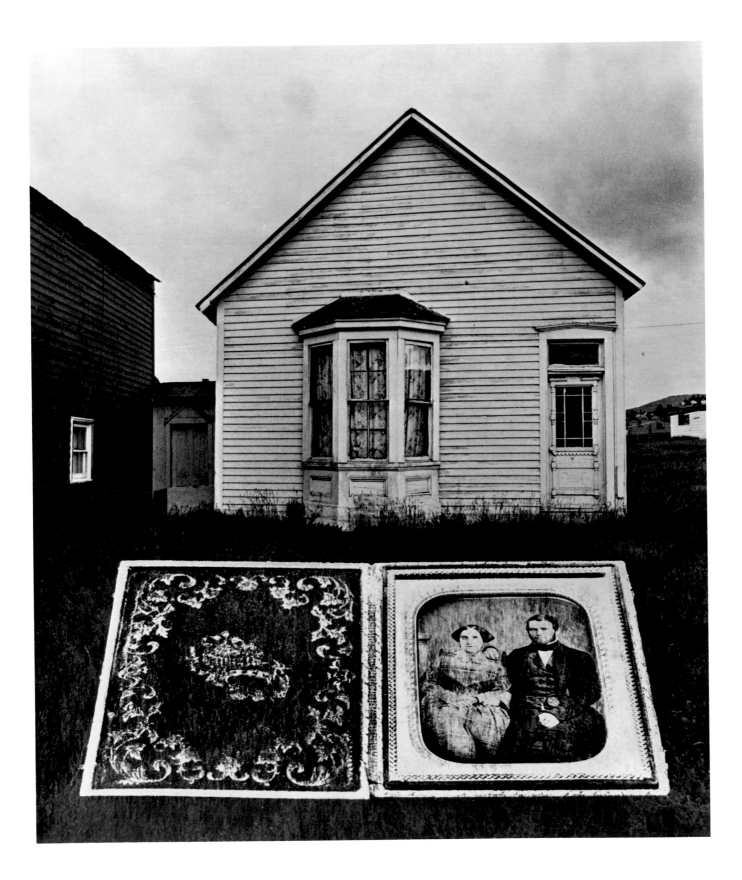

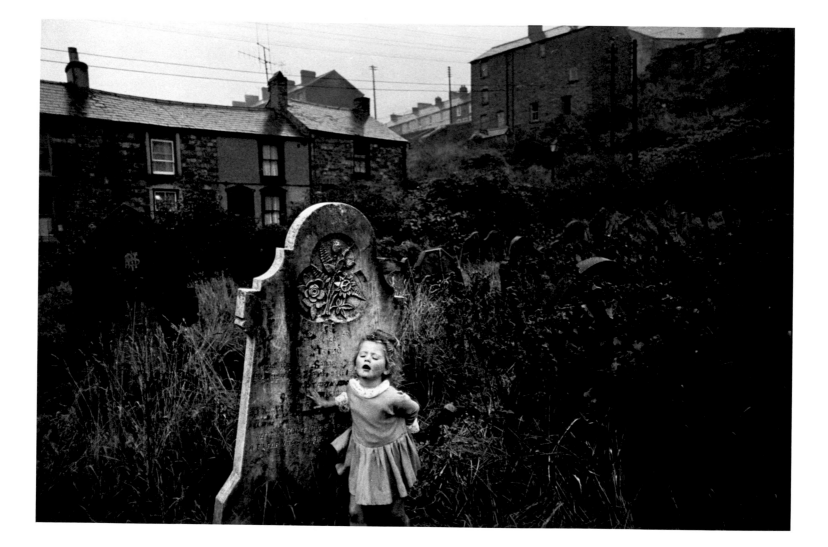

Bruce Davidson, untitled, 1965

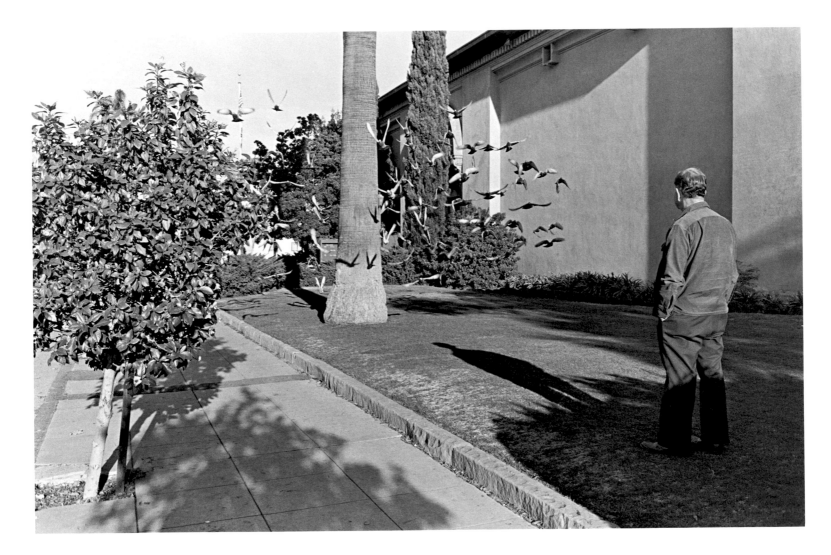

Henry Wessel, Jr., untitled, 1977

There is nothing as mysterious as a fact clearly described. . . . A still photograph is the illusion of a literal description of how a camera saw a piece of time and space. Understanding this, one can postulate the following theorem: Anything and all things are photographable . . . a photograph can look any way. Or, there's no way a photograph has to look (beyond being an illusion of a literal description). Or, there are no external or abstract or preconceived rules of design that can apply to still photographs.

GARRY WINOGRAND, 1974

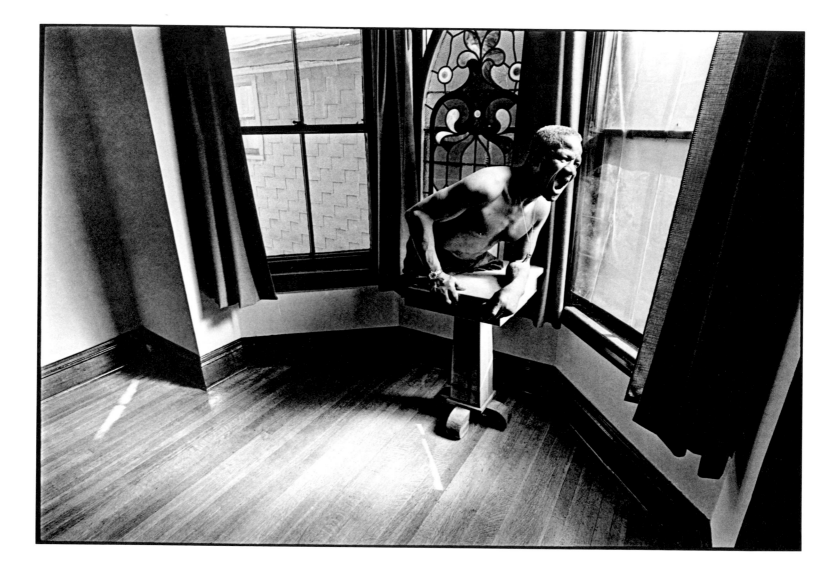

Leslie Krims, *A Human Being as a Piece of Sculpture,* 1969

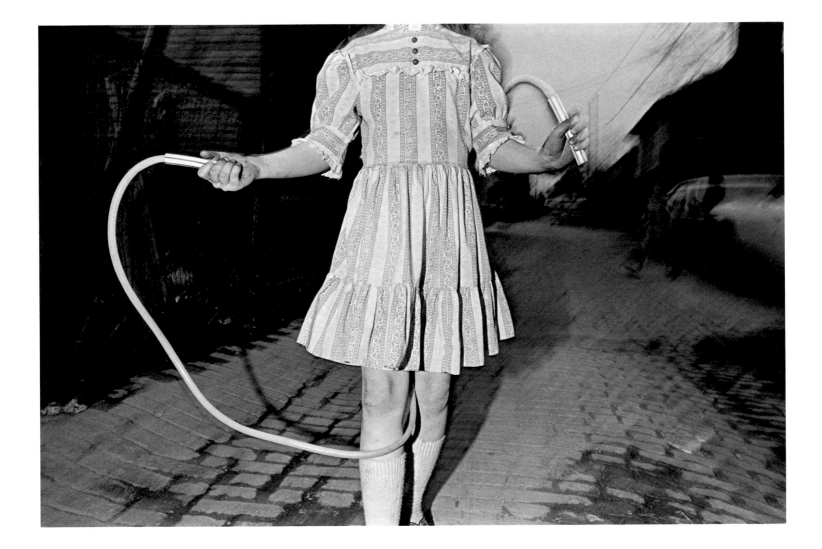

Mark Cohen, *Wilkes Barre, Pennsylvania,* 1975

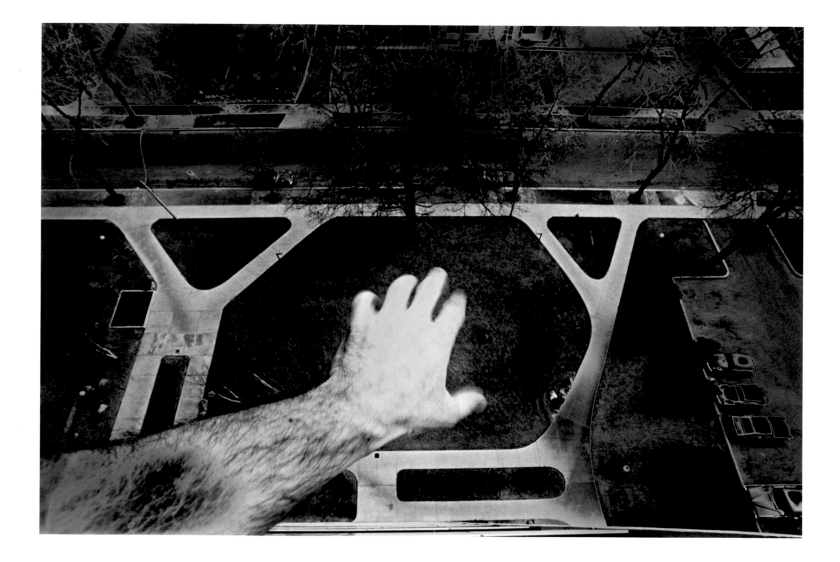

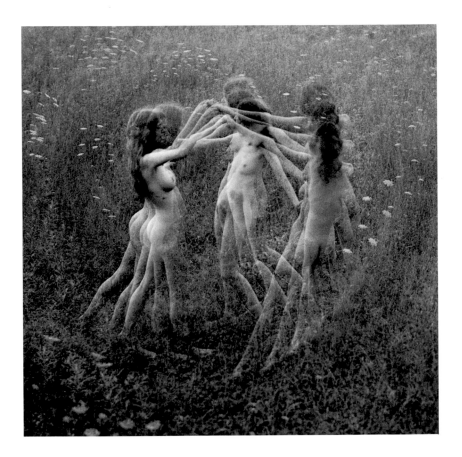

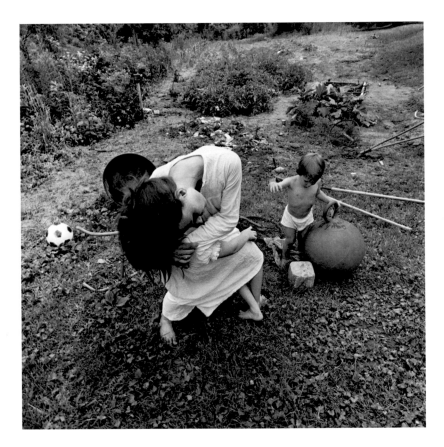

opposite: Roger Mertin, untitled, 1971

top: Charles Swedlund, *Three Graces,* 1969

bottom: Emmet Gowin, *Edith and Nancy, Danville, Virginia,* 1970

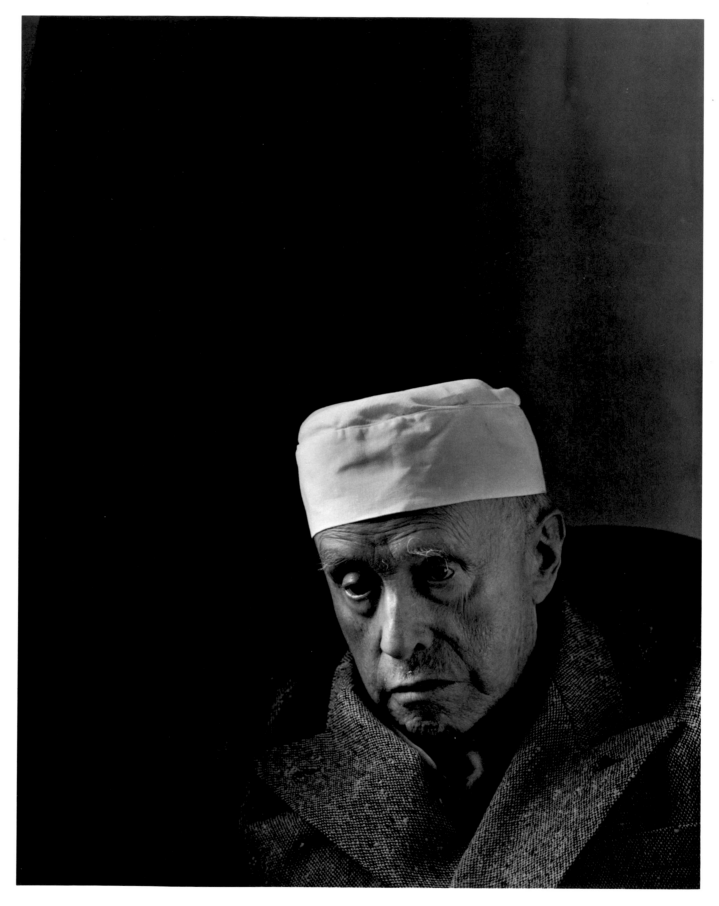

Arnold Newman, *Georges Rouault,* 1957

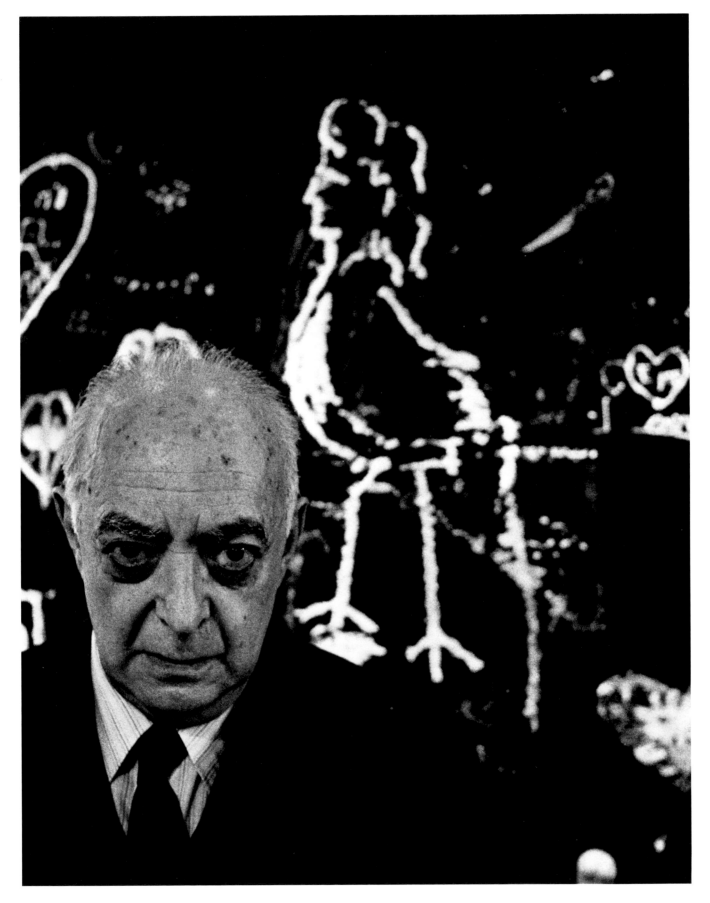

Arnold H. Crane, *Brassaï,* New York, 1968

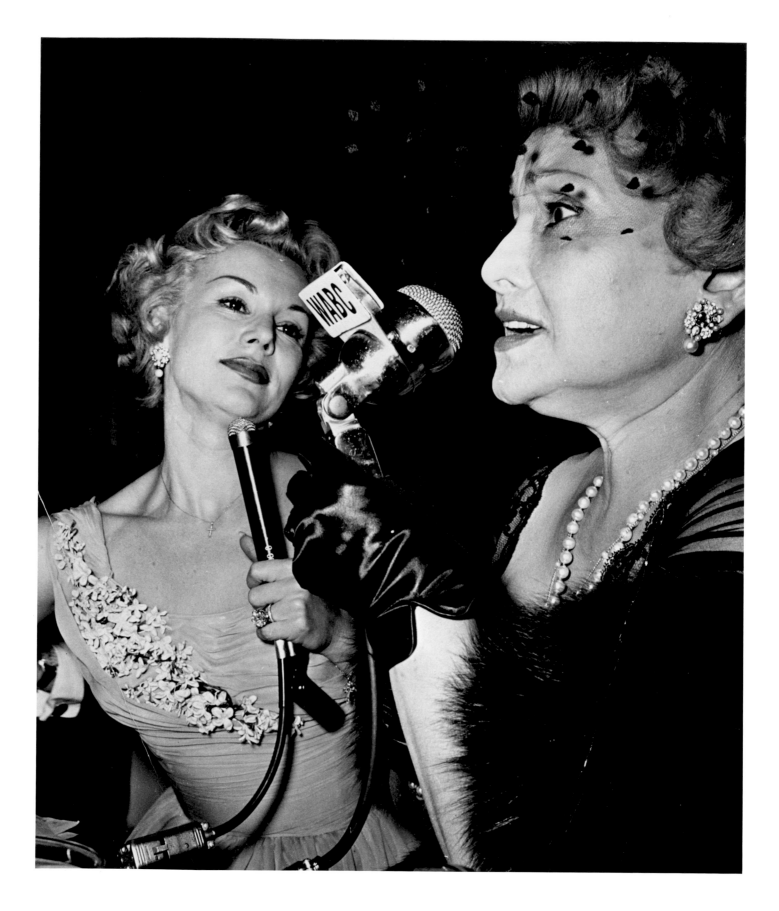

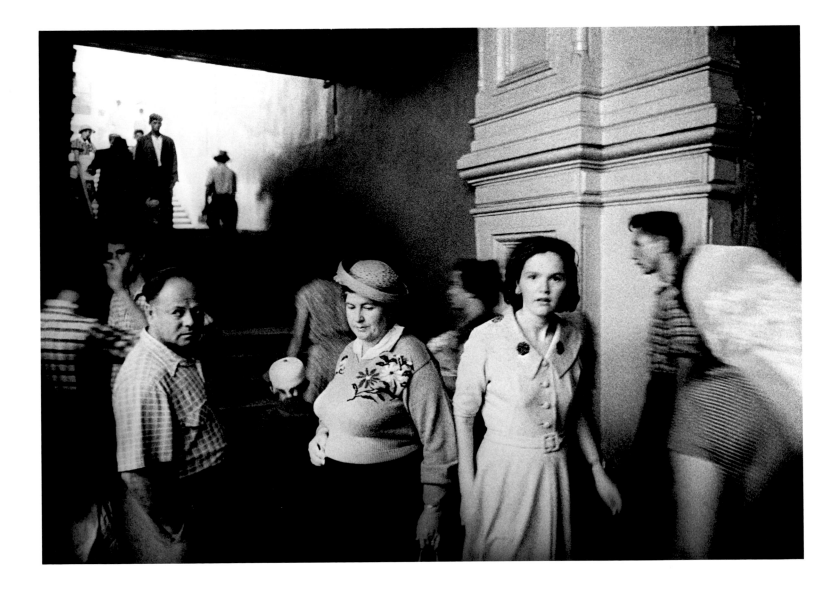

opposite: Weegee, *Eva Gabor and Mama Gabor,* n.d.

above: William Klein, *Inside Goum Department Store, Moscow,* 1959

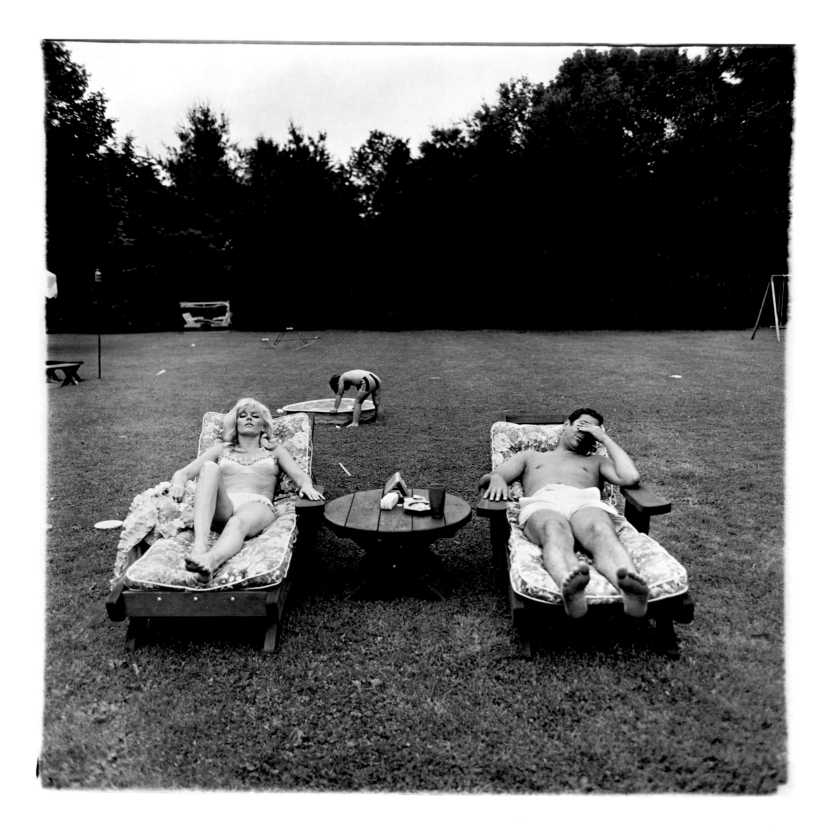

Diane Arbus, *Family on Lawn One Sunday, Westchester*, 1968

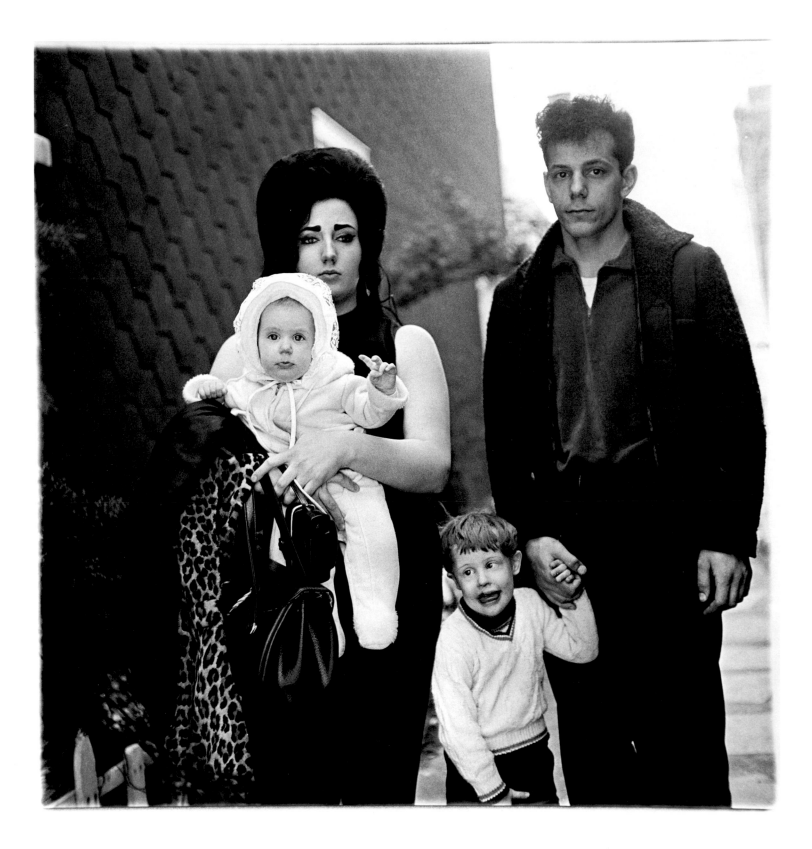

Diane Arbus, *Brooklyn Family on Sunday Outing,* 1966

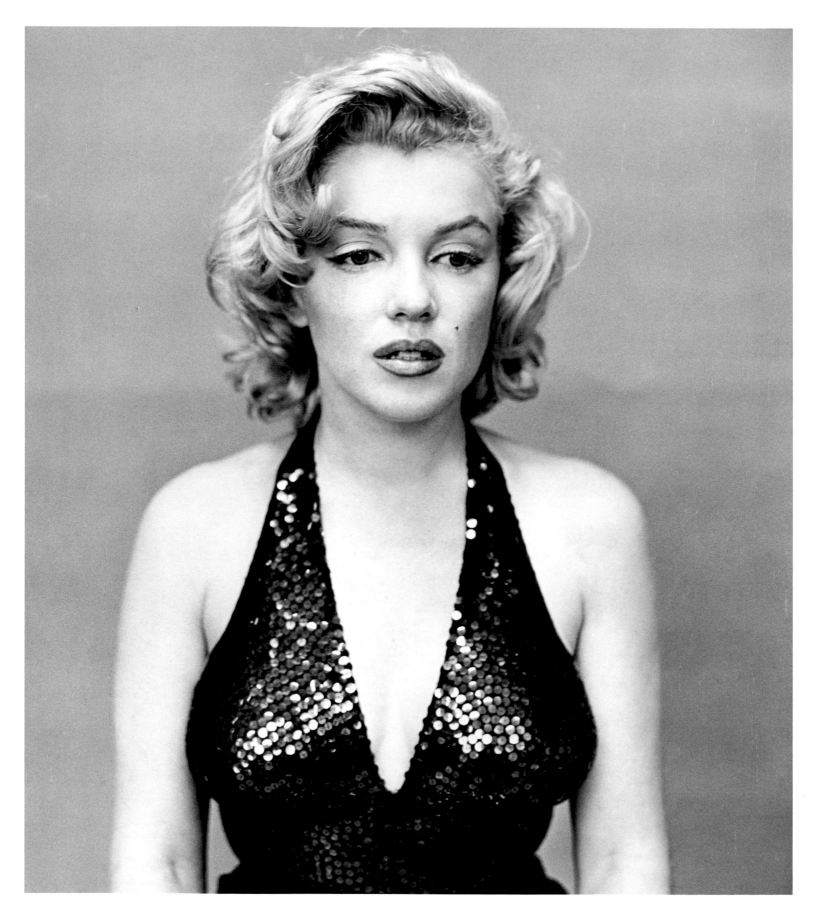

Richard Avedon, *Marilyn Monroe, Actress*, 1962

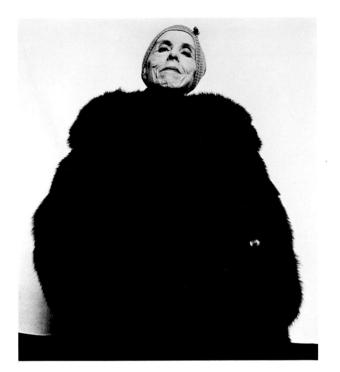

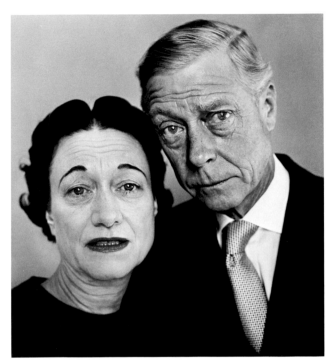

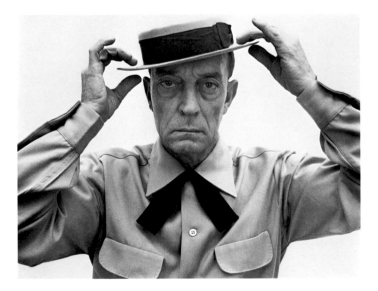

top left: Richard Avedon, *Isak Dinesen, Writer,* 1958
top right: Richard Avedon, *The Duke and Duchess of Windsor,* 1957
bottom: Richard Avedon, *Buster Keaton, Comedian,* 1952

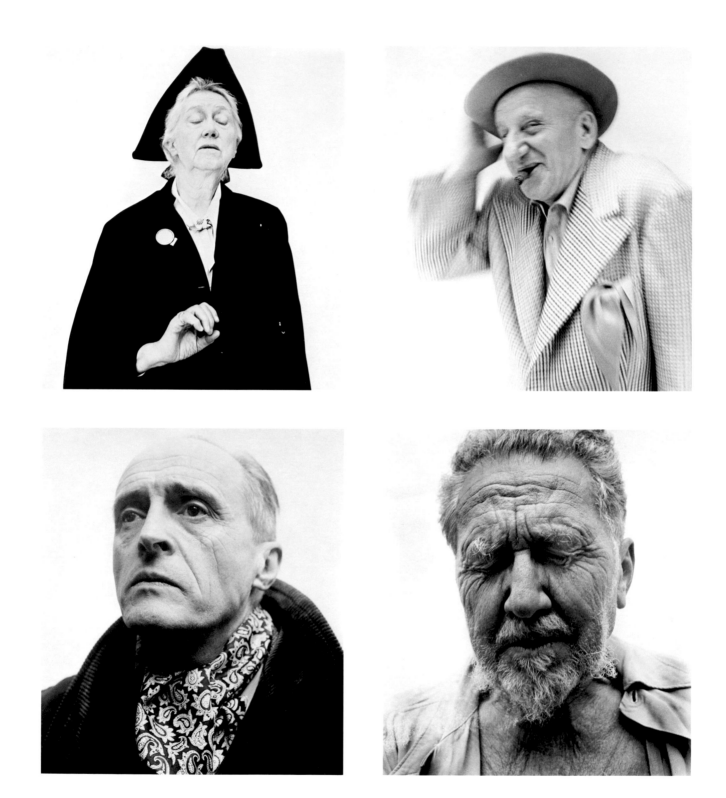

top: Richard Avedon, *Marianne Moore, Poetess,* 1958
bottom: Richard Avedon, *René Clair, Director,* 1958

top: Richard Avedon, *Jimmy Durante, Comedian,* 1953
bottom: Richard Avedon, *Ezra Pound, Poet,* 1958

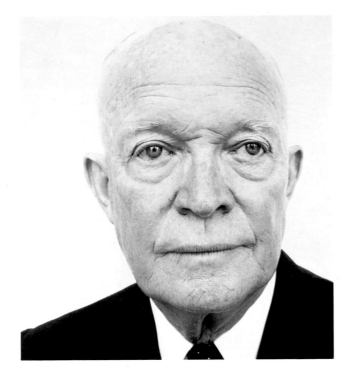

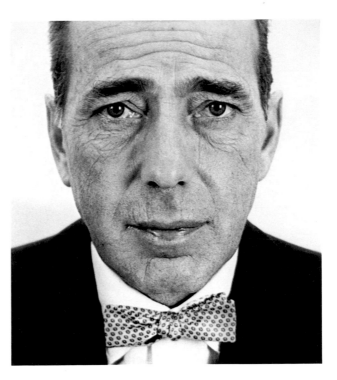

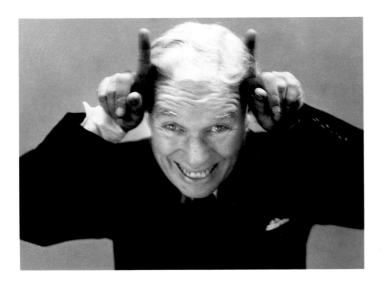

I work out of myselves. There's no other way to do it. All these photographs are linked through me and each is like a sentence in one long inner argument. . . . The photographs have a life of their own now. Whatever it was I brought to them is in *them* and it isn't in me . . . anymore. The photograph of Bogart hangs on the wall. The information in it is self-contained. He's dead. The time is past. Everything has changed. Everything . . . except the photograph.

My photographs don't go below the surface. They don't go below anything. They're readings of what's on the surface. I have great faith in surfaces. A good one is full of clues.

RICHARD AVEDON, 1970

top left: Richard Avedon, *Dwight David Eisenhower, President of the United States,* 1964
top right: Richard Avedon, *Humphrey Bogart, Actor,* 1953
bottom: Richard Avedon, *Charles Chaplin, Actor,* 1952

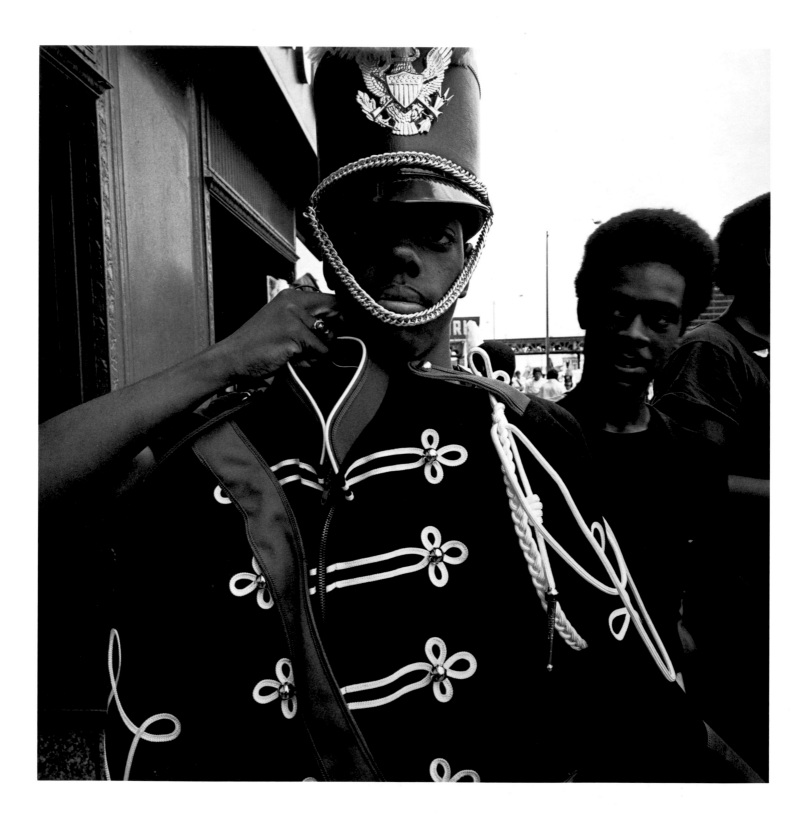

Jonas Dovydenas, *Amvets Parade Bugler, Chicago,* 1975

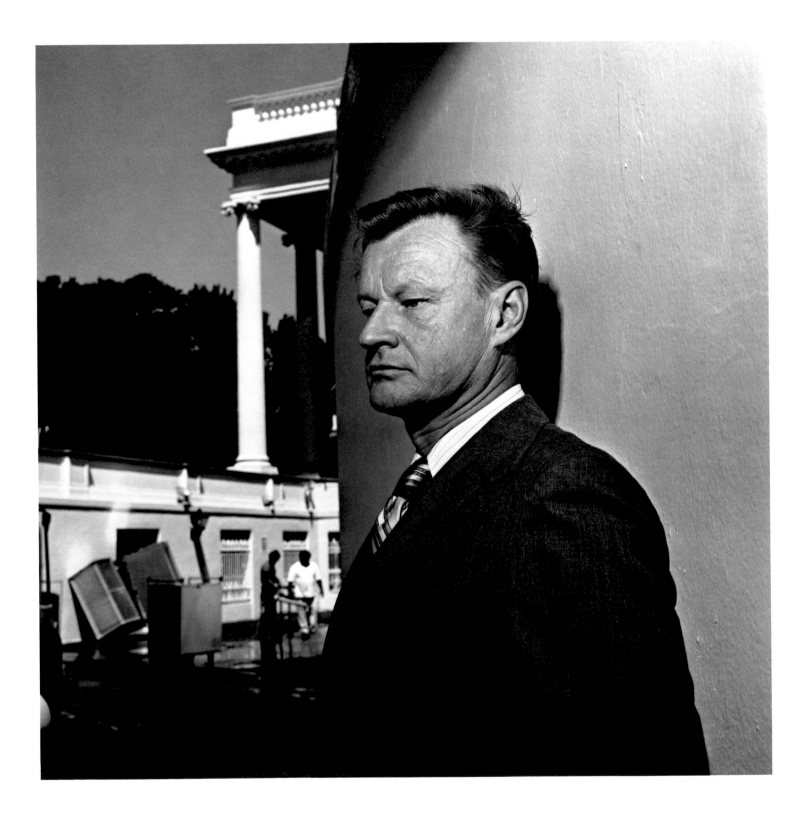

Neil Selkirk, *Zbigniew Brzezinski, Washington, D.C.,* 1978

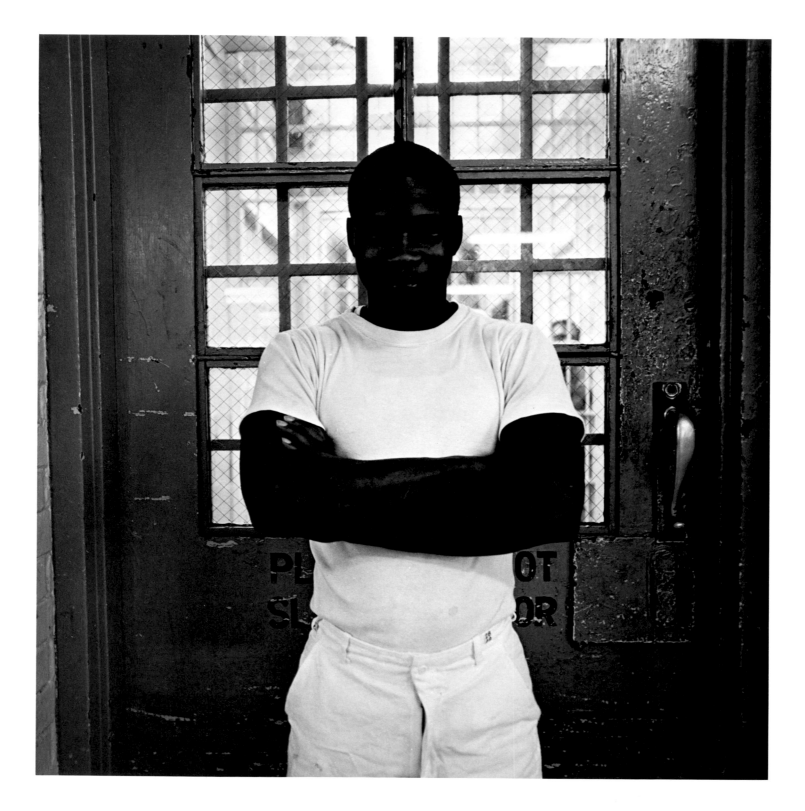

Joel Snyder, *Rebo, Chester, Illinois,* 1975

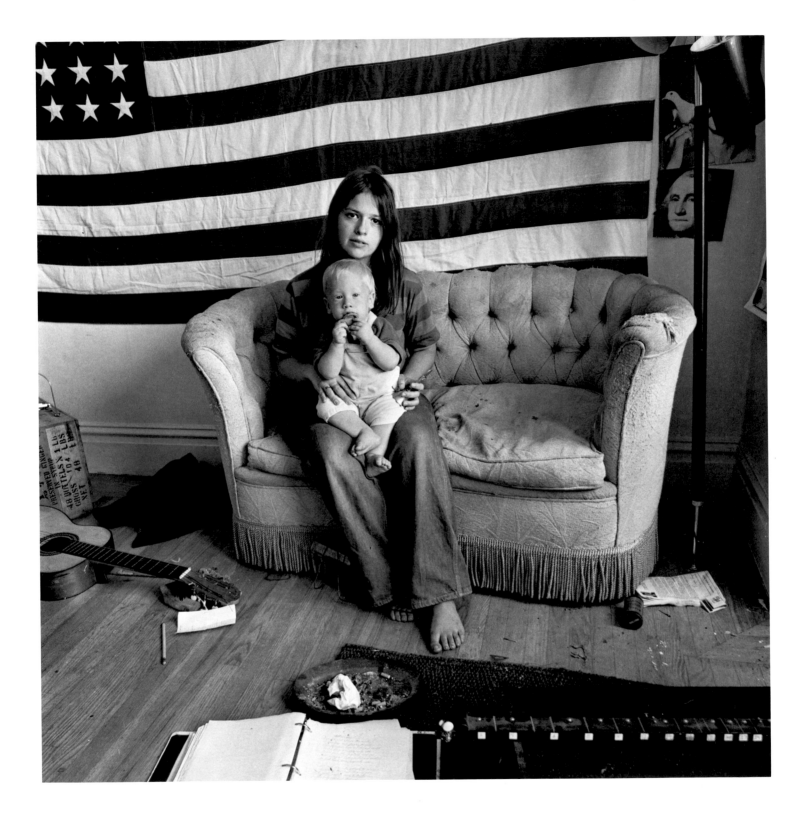

Elaine Mayes, *Kathleen and Max Demian Goldman, Ages Twenty-two and One Year, Cole Street, San Francisco,* 1968

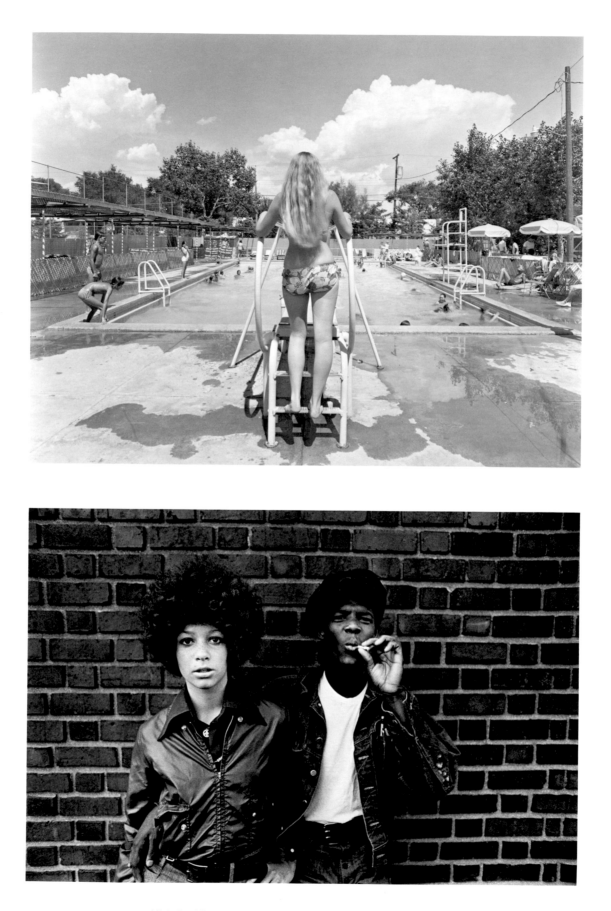

top: Nicholas Nixon, *Mary Hughes, Tennis Club of Albuquerque,* 1973
bottom: Richard Olsenius, from *High School* series, c. 1970

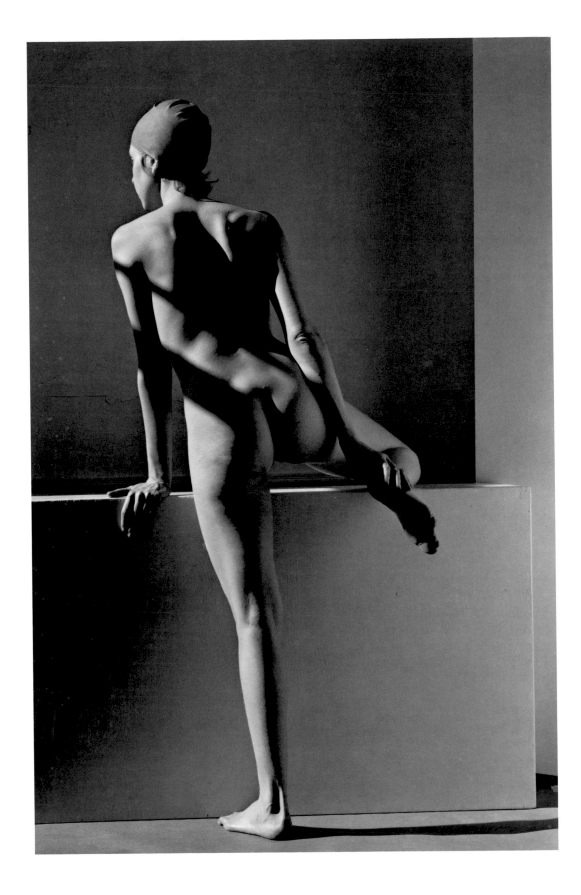

Marsha Burns, *#45006,* 1978

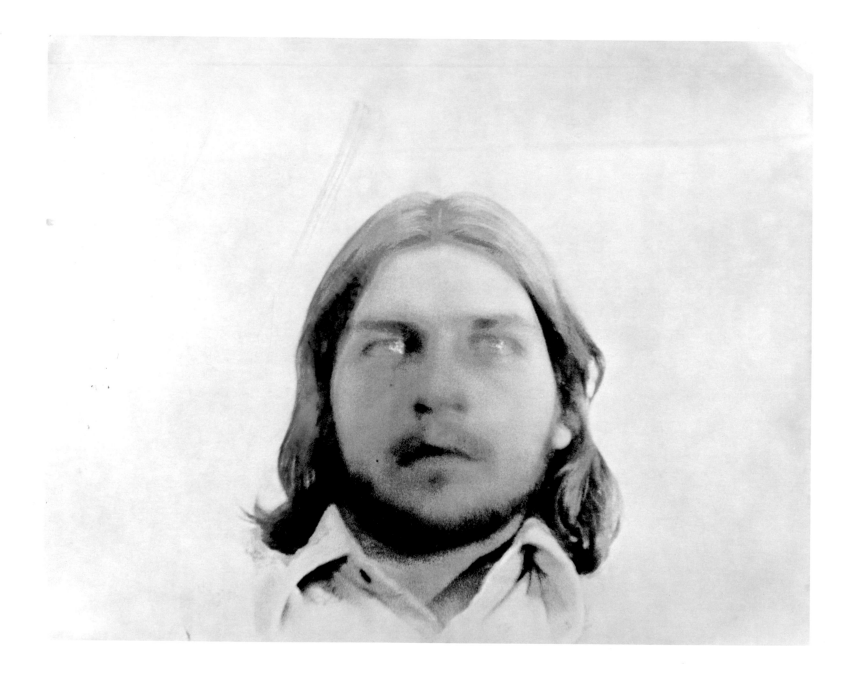

Peter Goin, *Jim,* 1977

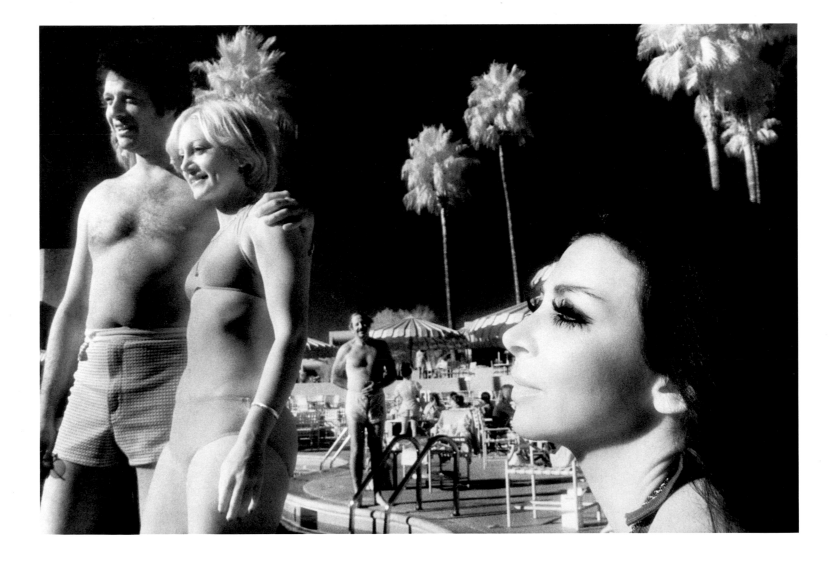

Joan Moss, from *Two Women* series, 1977

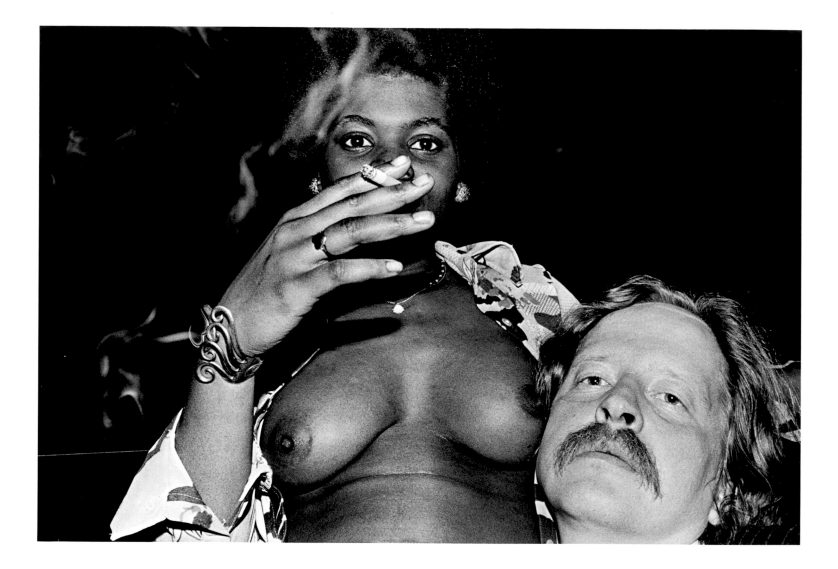

Ramon J. Muxter, *Baltimore Street,* 1976

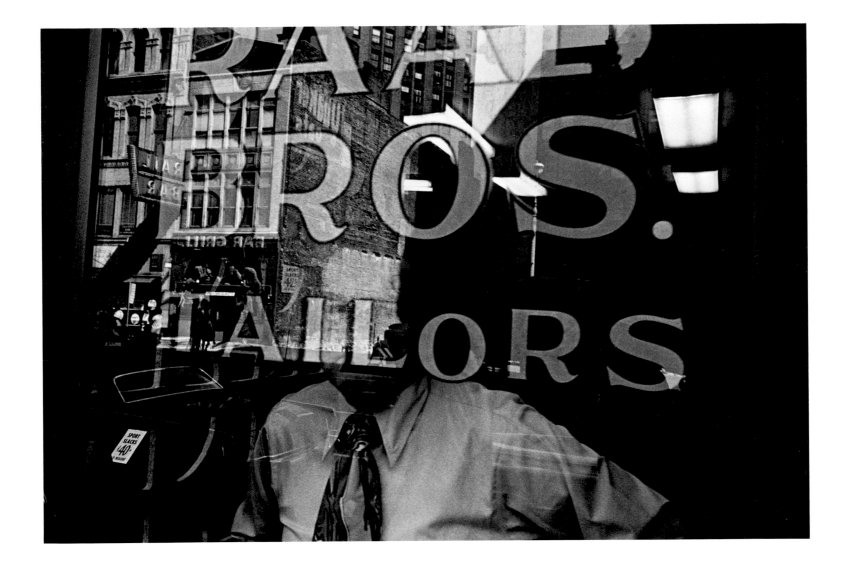

Michael Dickey, *Detroit,* 1972

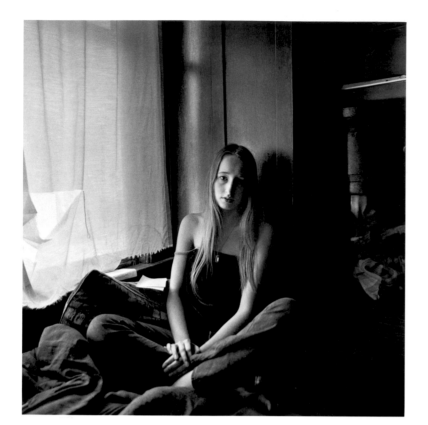

left: Elaine Mayes, *Ruth Murphey, Age Eighteen, Mission District*, San Francisco, 1968

bottom: Larry Fink, *First Communion, Bronx, New York,* 1961

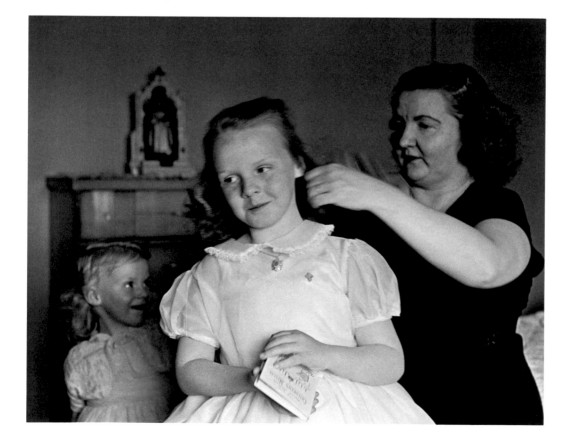

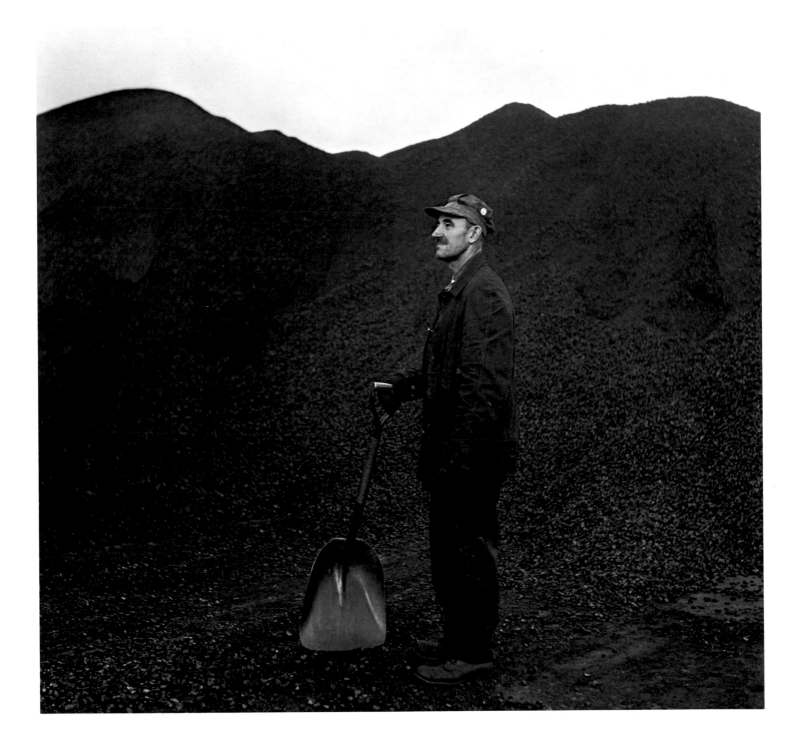

Jerome Liebling, *Coal Worker, Minnesota,* 1952

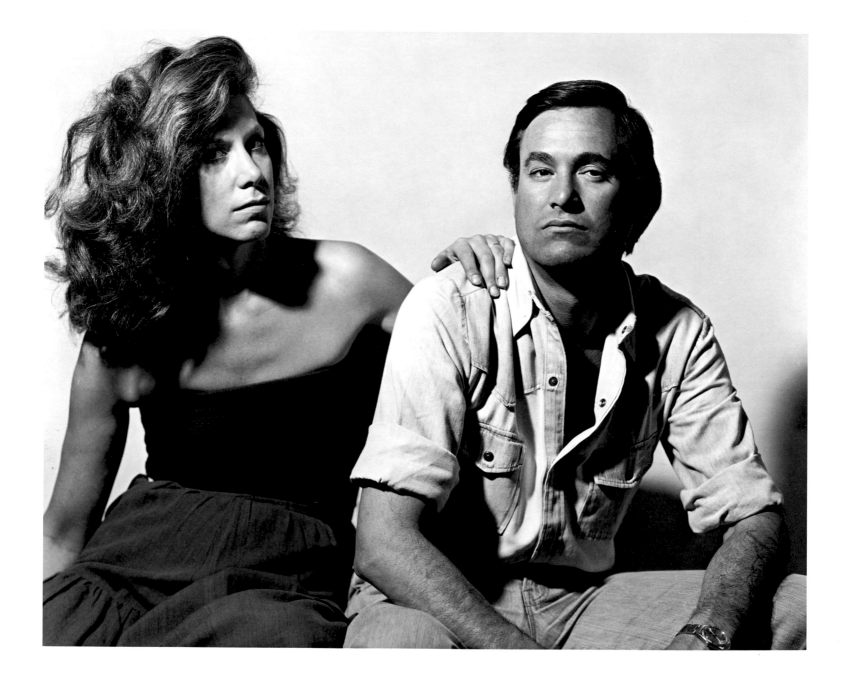

John Coplans, *Judith and Inigo,* 1980

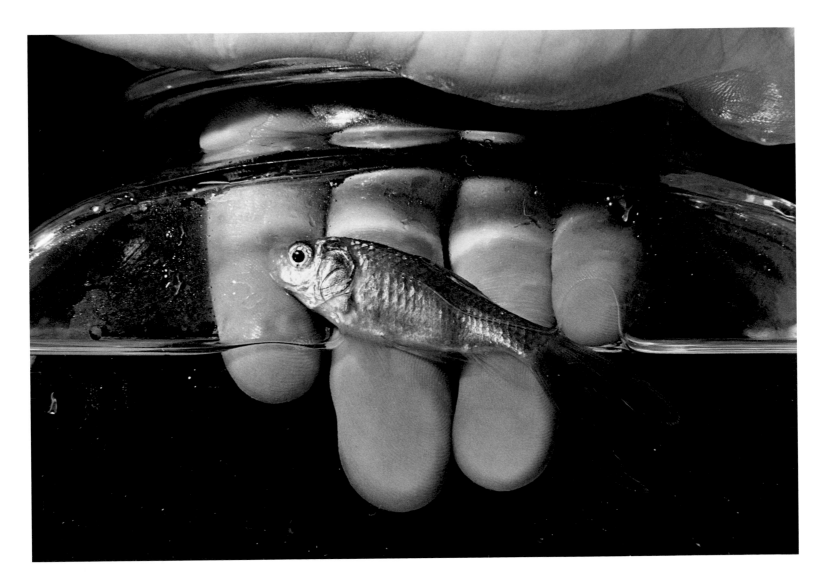

Robert Holmgren, untitled, 1979

The aesthetic qualities of photography are to be sought in its power to lay bare the realities. . . . Only the impassive lens, stripping its object of all those ways of seeing it, those piled-up preconceptions, that spiritual dust and grime with which my eyes have covered it, is able to present it in all its virginal purity to my attention and consequently to my love. By the power of photography, the natural image of a world that we neither know nor can know, nature at last does more than imitate art; she imitates the artist.

ANDRÉ BAZIN, 1967

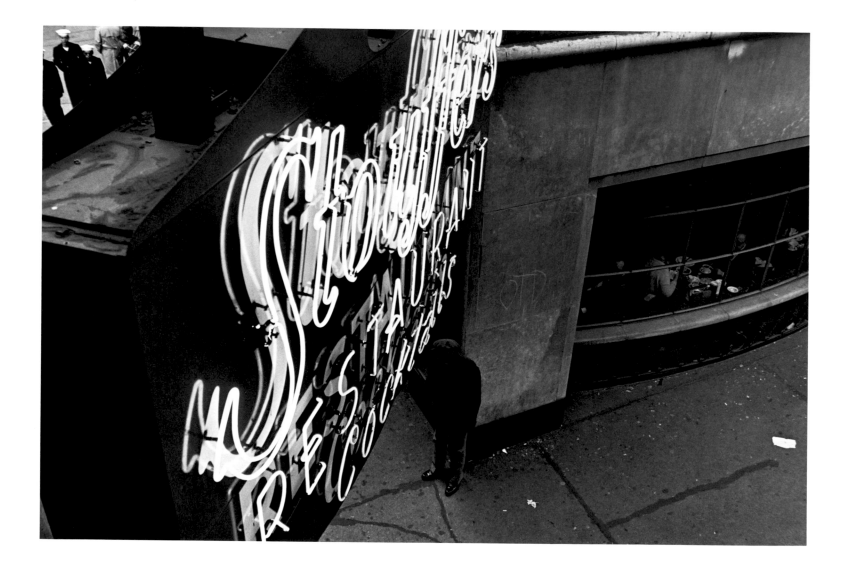

above: Thomas F. Arndt, *Street Scene, Chicago,* 1980
opposite: Louis Lanzano, untitled, 1973

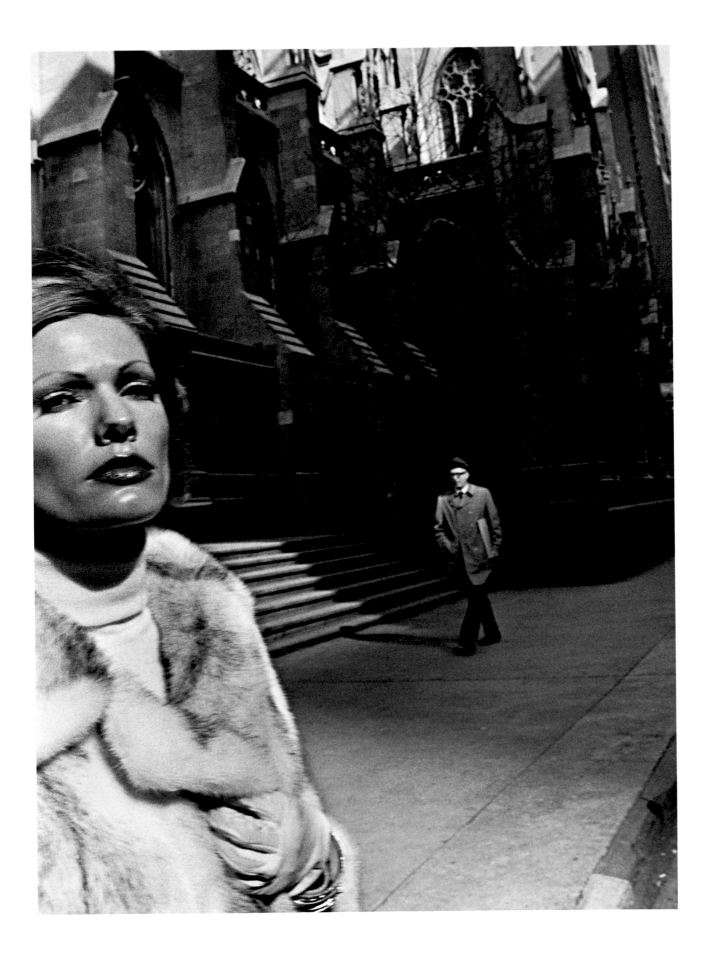

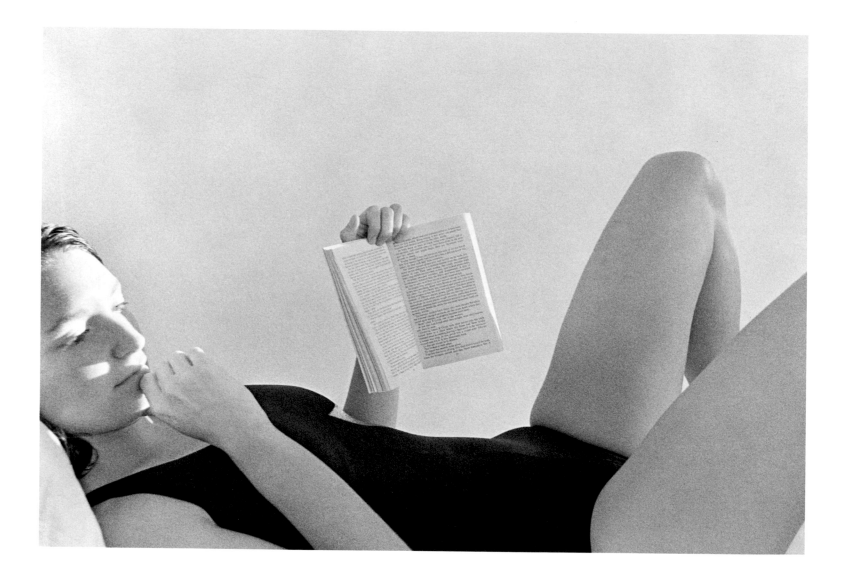

above: Peter DeLory, *Andy Ostheimer Reading, Ibiza, Spain,* 1976
opposite, top: Eve Sonneman, *Light on Lead Street, New Mexico,* 1968
bottom: Gerald Lang, *Zion,* 1975

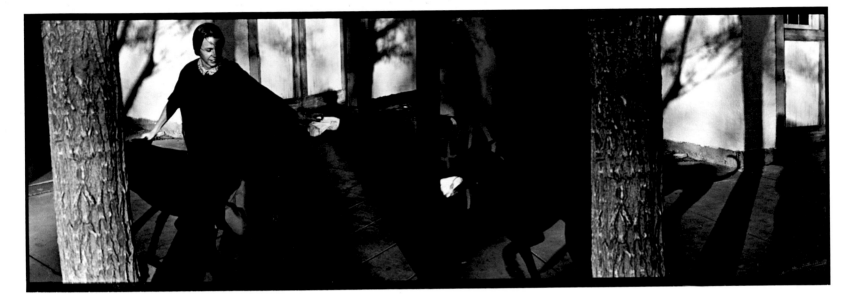

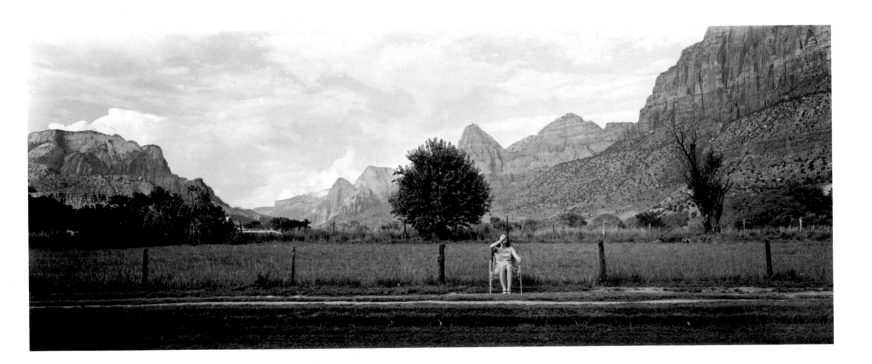

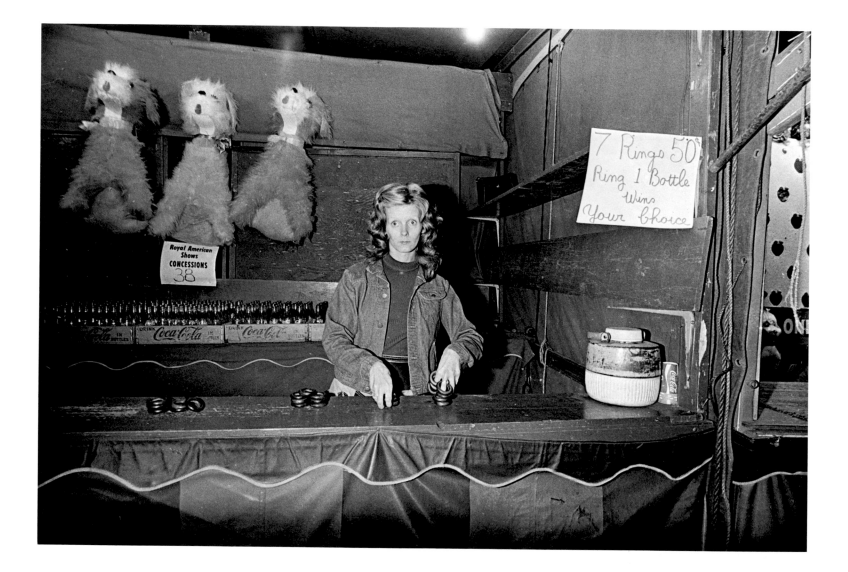

above: Thomas F. Arndt, *Midway Worker, Minnesota State Fair,* 1974
opposite: Mark E. Jensen, *Linus Mullarkey, Barber, Milwaukee, Wisconsin,* 1974

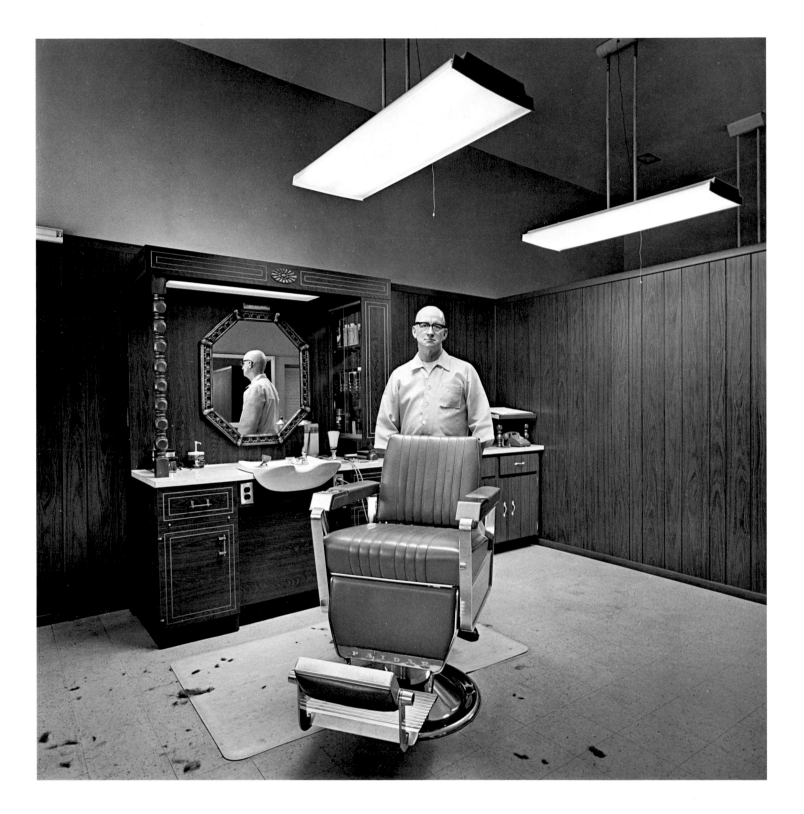

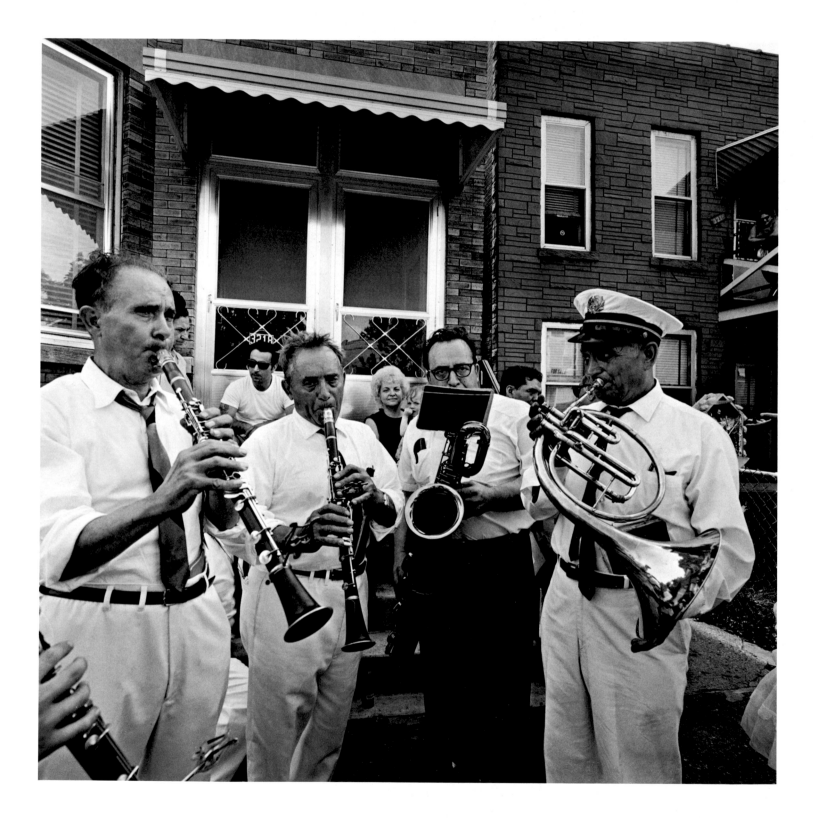

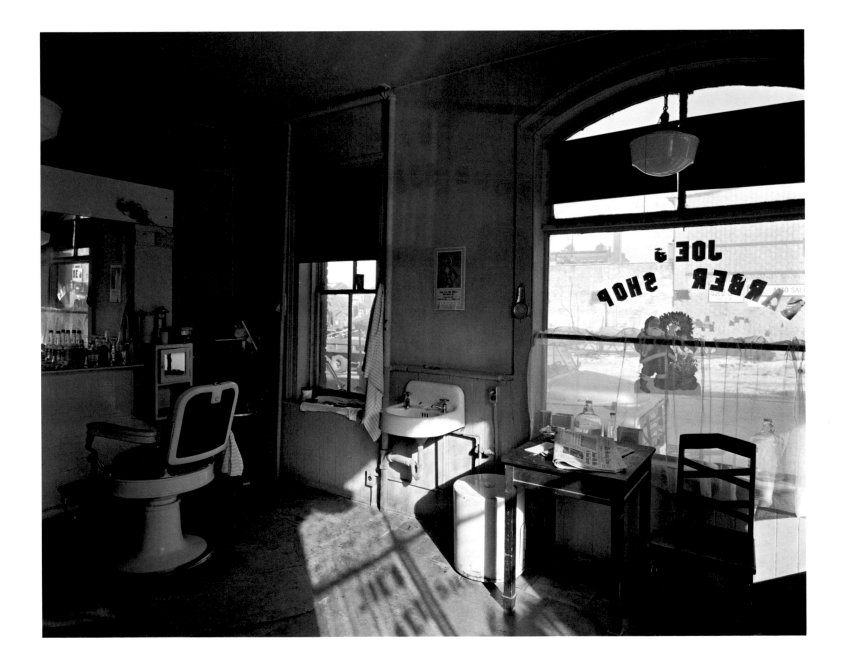

opposite: Jonas Dovydenas, *Church Holiday Musicians, Chicago,* 1968
above: George A. Tice, *Joe's Barber Shop, Paterson, New Jersey,* 1970

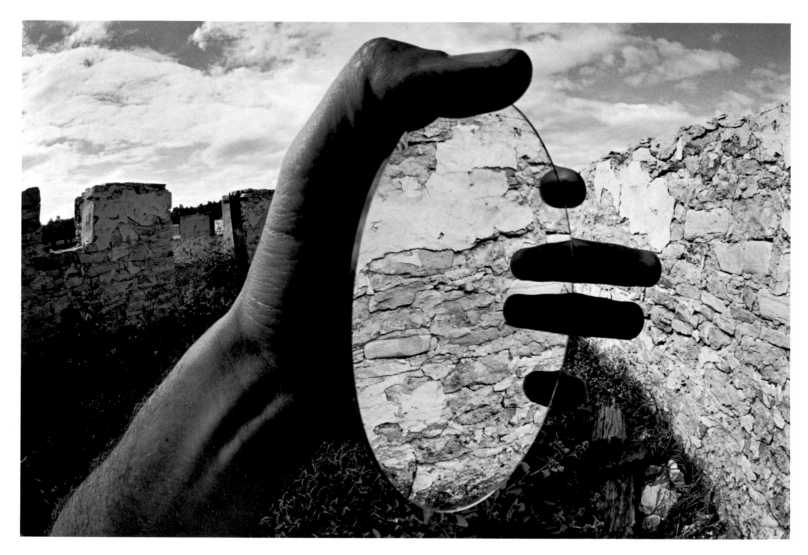

Joseph D. Jachna, *Door County, Wisconsin,* 1970

The artist is simply the more or less appropriate *instrument* through which a culture . . . expresses itself aesthetically.

PIET MONDRIAN, 1918

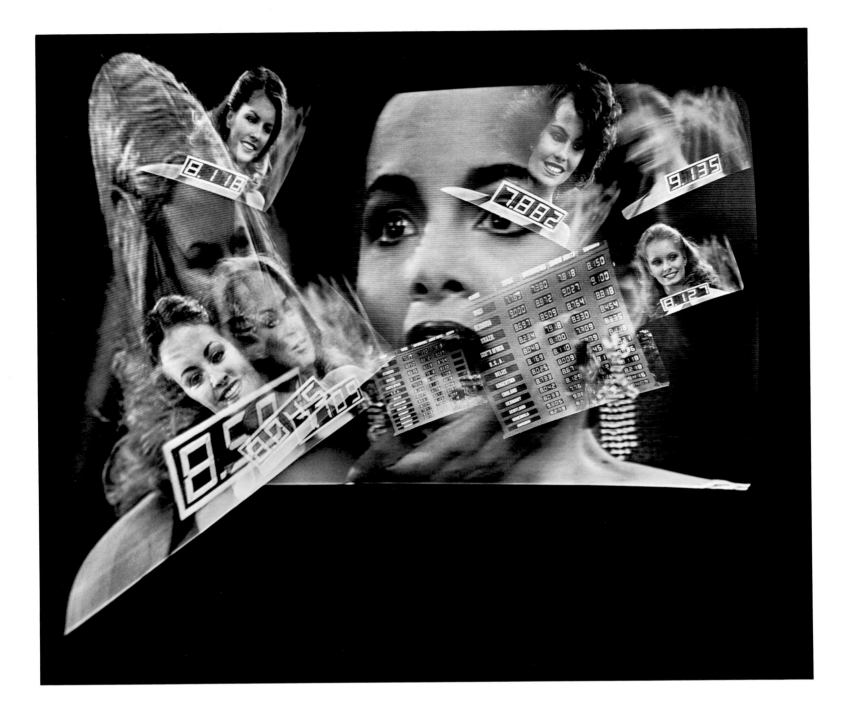

Joel D. Levinson, *Fractions,* from *Self-Indulgence* series, 1979

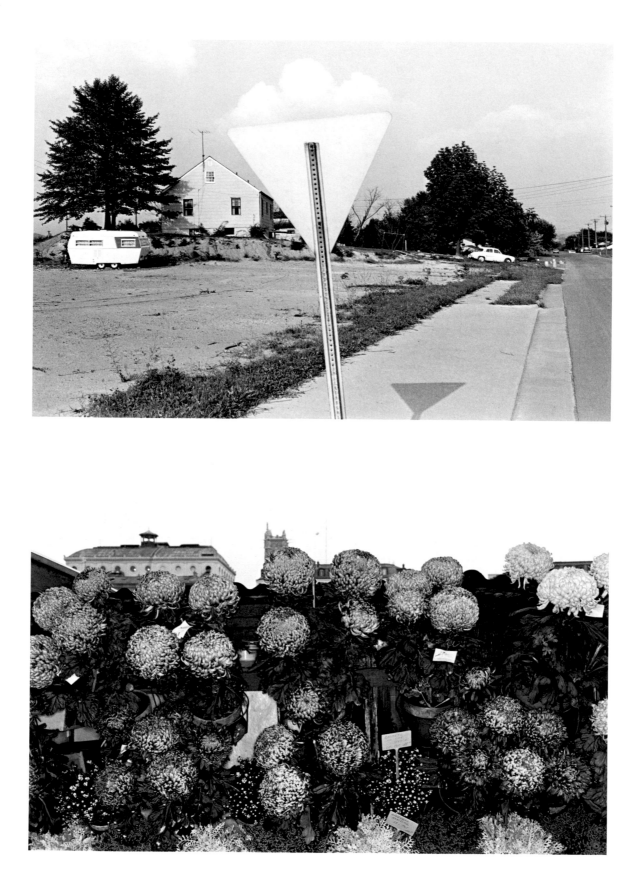

top: Lee Friedlander, *House, Trailer, Sign, and Cloud, Knoxville, Tennessee,* 1971
bottom: Lee Friedlander, *Chrysanthemums at Flower Market, Paris,* 1972

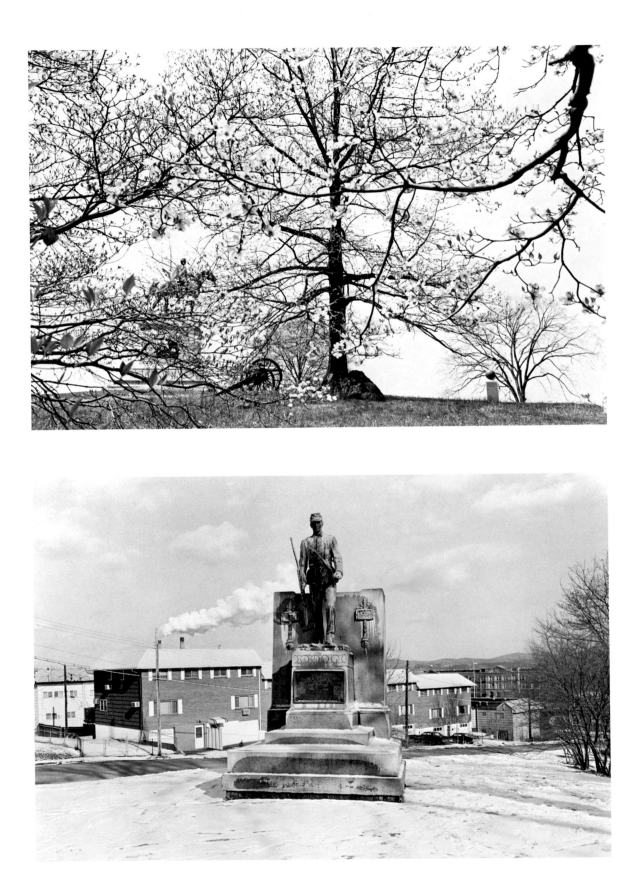

top: Lee Friedlander, *Major General Henry W. Slocum, Napoleon Gun, and Stevens'
Fifth Maine Battery Marker, Gettysburg National Military Park,* 1974
bottom: Lee Friedlander, *Grand Army of the Republic Memorial, Haverstraw, New York,* 1976

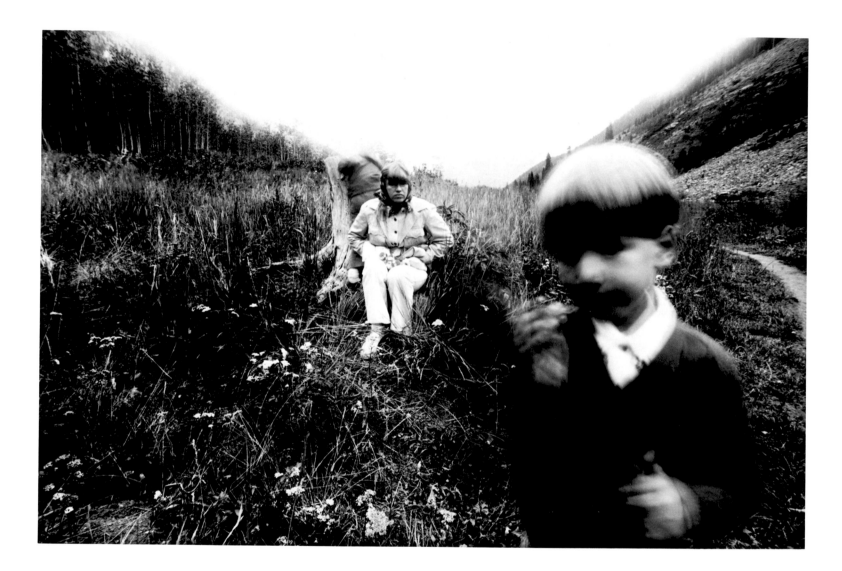

Michael Simon, untitled, 1973

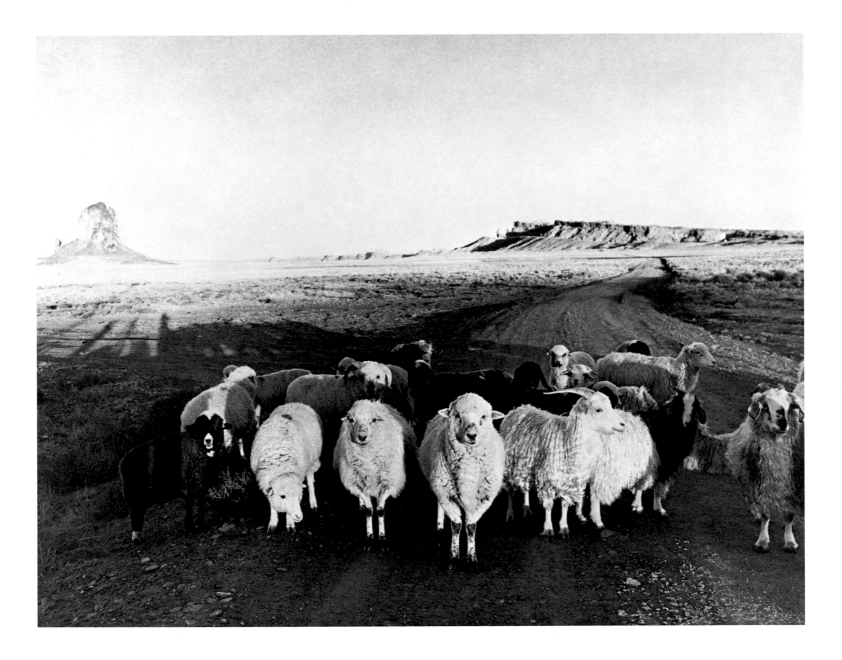

Joan Myers, *Monument Valley*, 1979

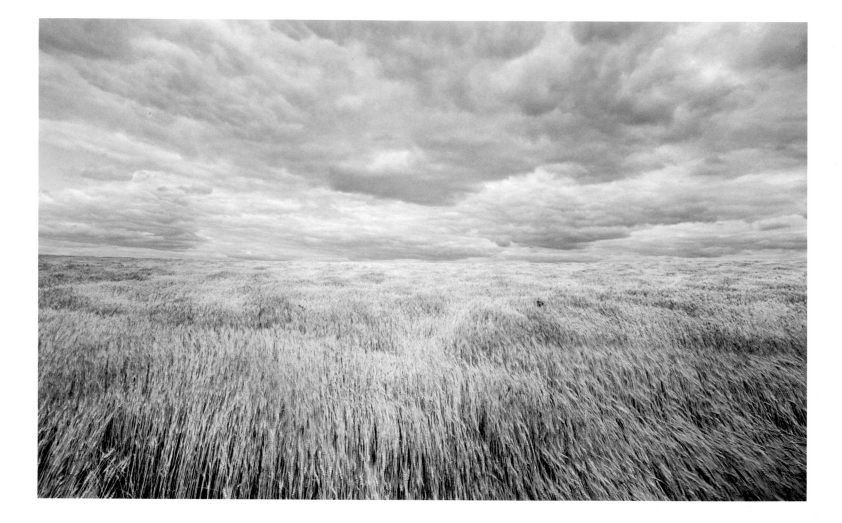

above: Lawrence McFarland, *Wheatfield, Near Kansas/Nebraska Border,* 1976
opposite: Joe Deal, *View, Magic Mountain, Valencia, California,* 1977

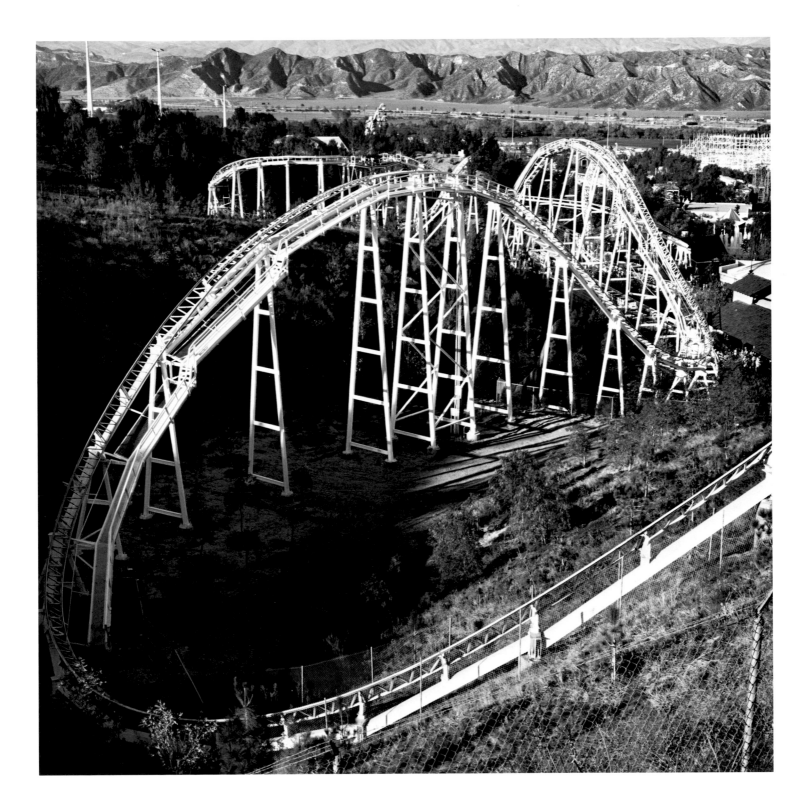

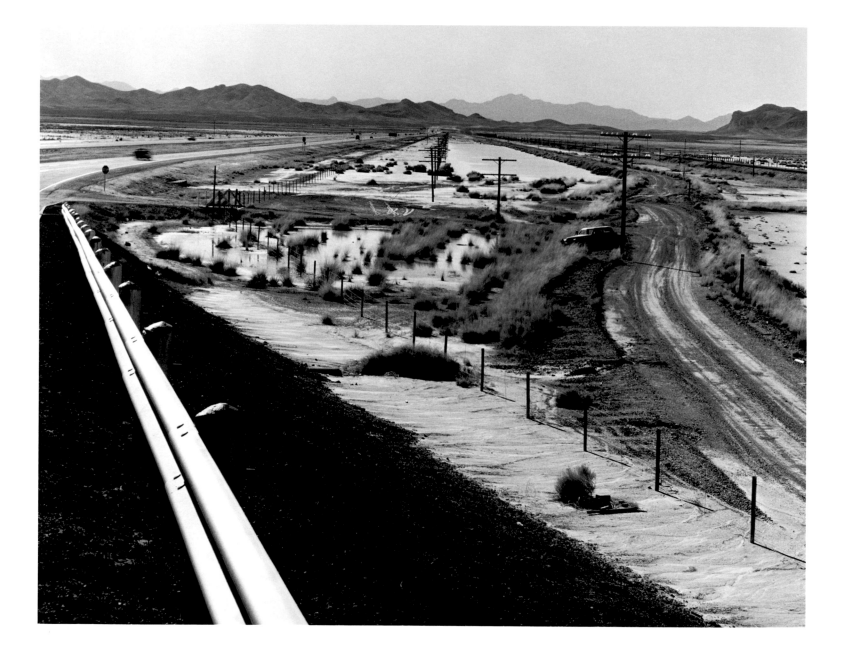

above: Will Agar, *Freeway, Southwest U.S.A.,* 1975
opposite, top: Thomas F. Barrow, from *Cancellations* series, 1975
bottom: Allen Swerdlowe, untitled, 1978

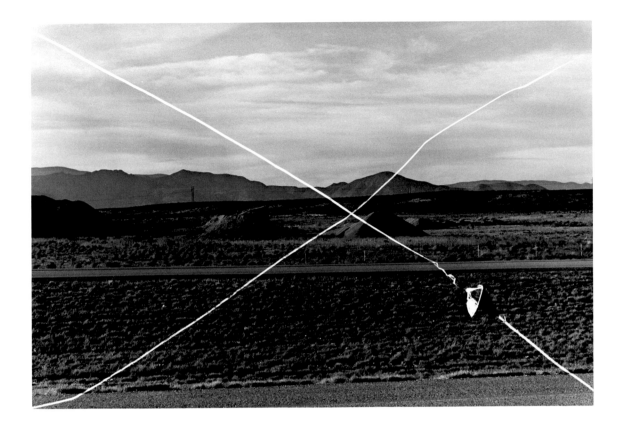

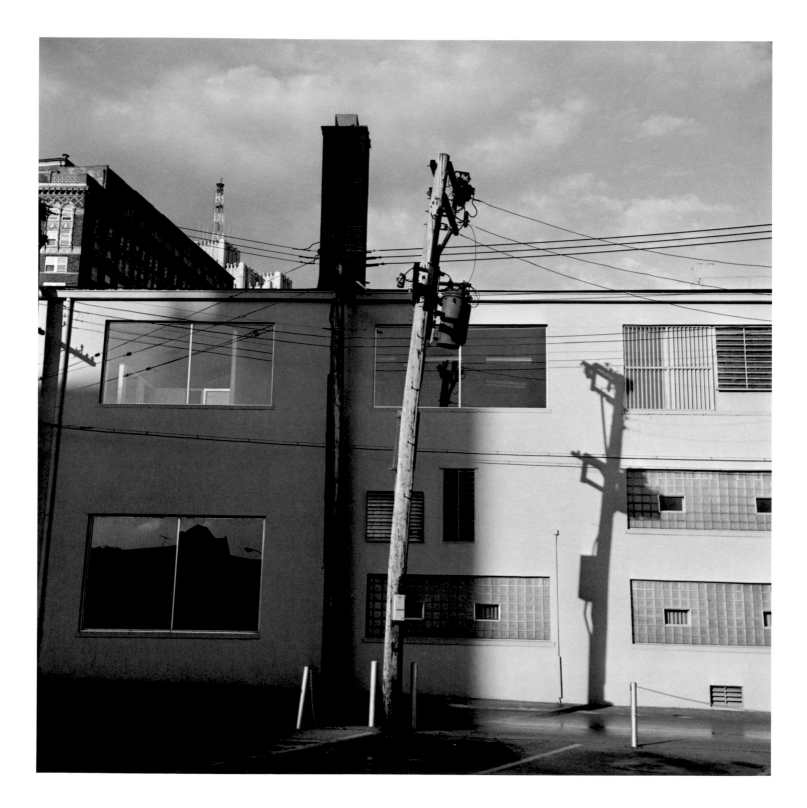

above: Frank W. Gohlke, *Facade and Telephone Pole, St. Louis, Missouri,* 1972
opposite: Michael A. Smith, *Yellowstone National Park, Wyoming,* 1975

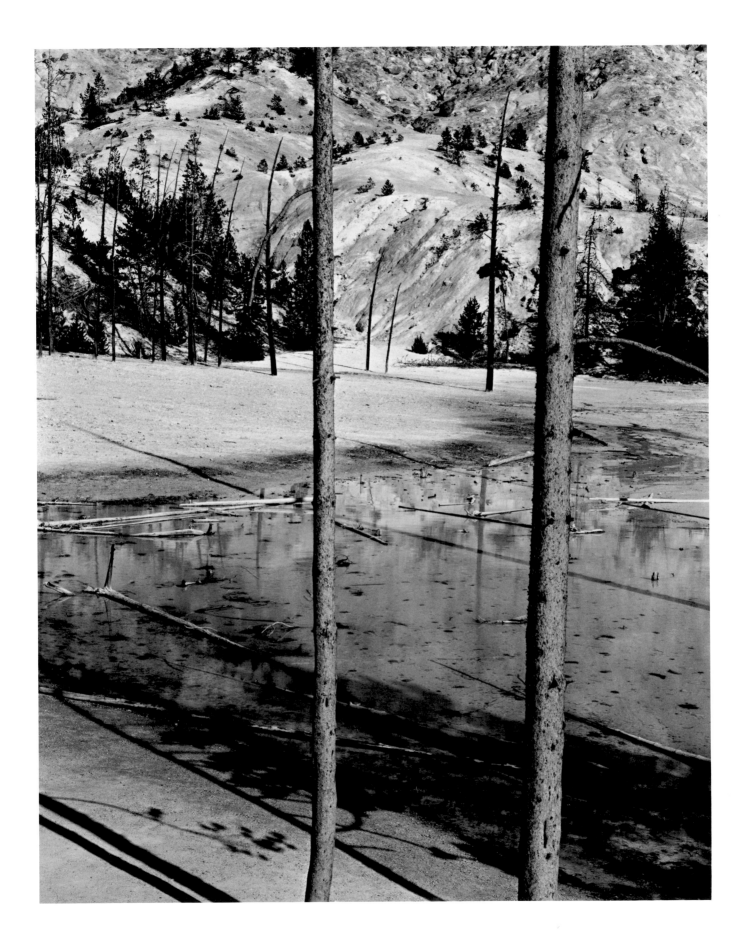

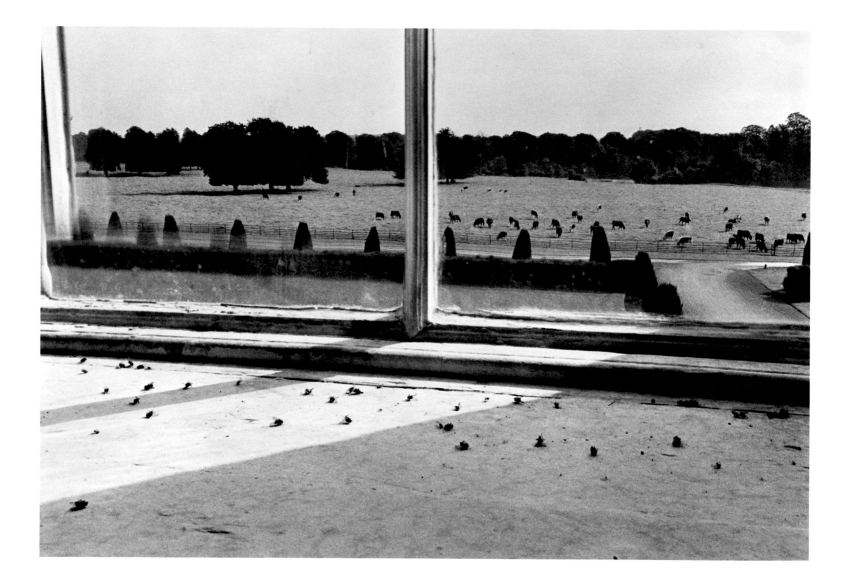

above: Alen MacWeeney, *Flies in the Window,*
Castletown House, Ireland, 1972
opposite: Jane Tuckerman, untitled, 1980

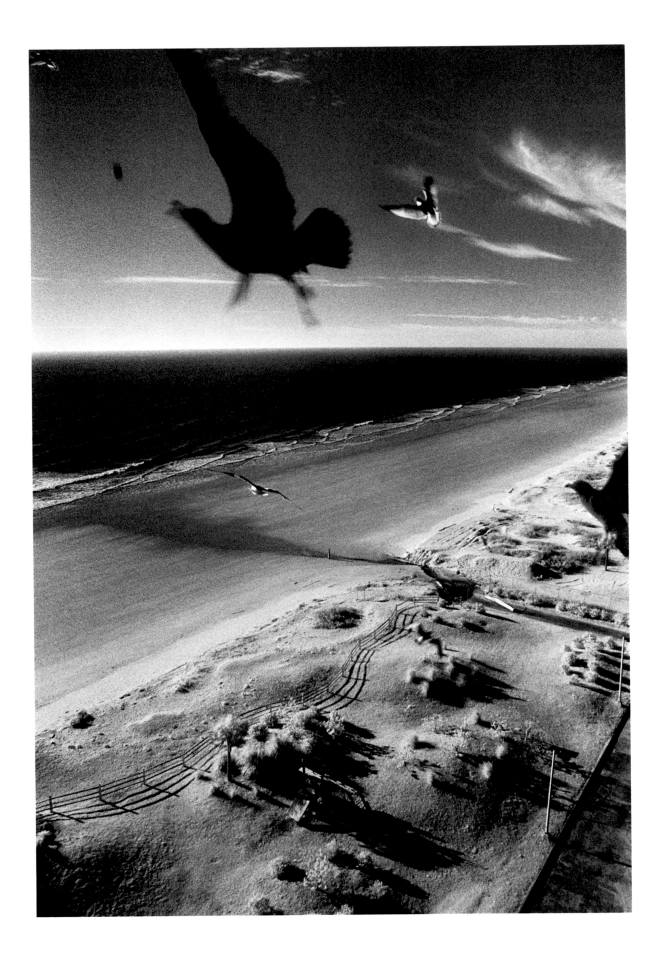

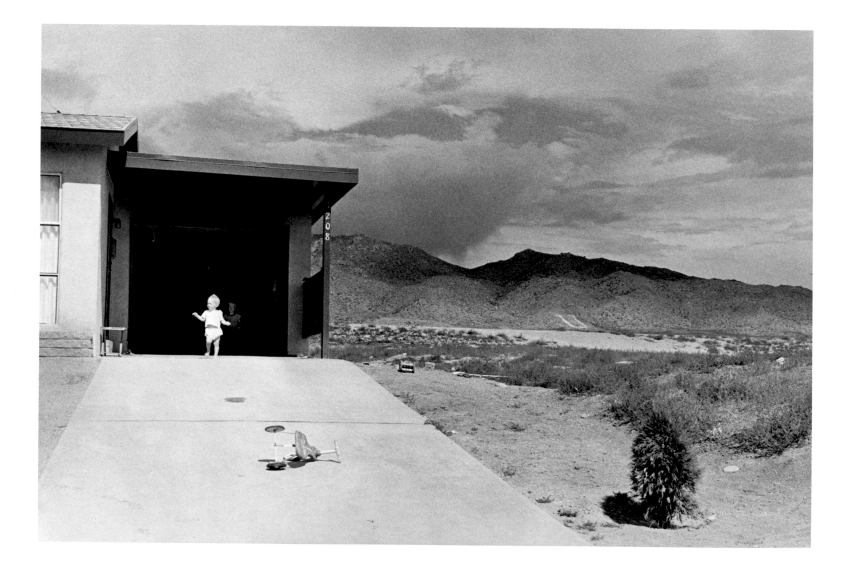

Garry Winogrand, *Albuquerque, New Mexico,* 1958

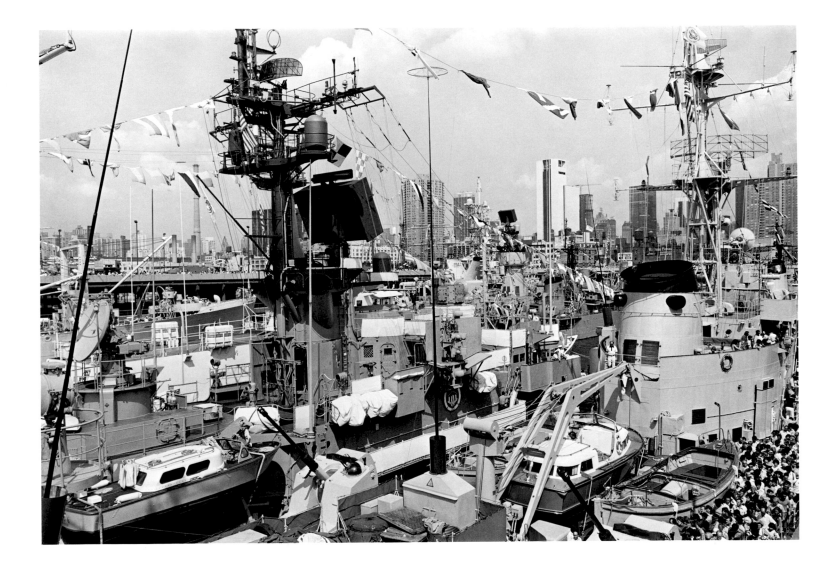

Tod Papageorge, *New York Pier, July 5, 1976*

Thus photography, from being merely another way of procuring or making images of things already seen by our eyes, has become a means to ocular awareness of things that our eyes can never see directly. It has become the necessary tool for all visual comparison of things that are not side by side, and for all visual knowledge of the literally unseeable—unseeable whether because too small, too fast, or hidden under surfaces, and because of the absence of light. Not only has it vastly extended the gamut of our visual knowledge, but through its reproduction in the printing press, it has effected a very complete revolution in the ways we use our eyes and, especially, in the kinds of things our minds permit our eyes to tell us.

WILLIAM M. IVINS, JR., 1953

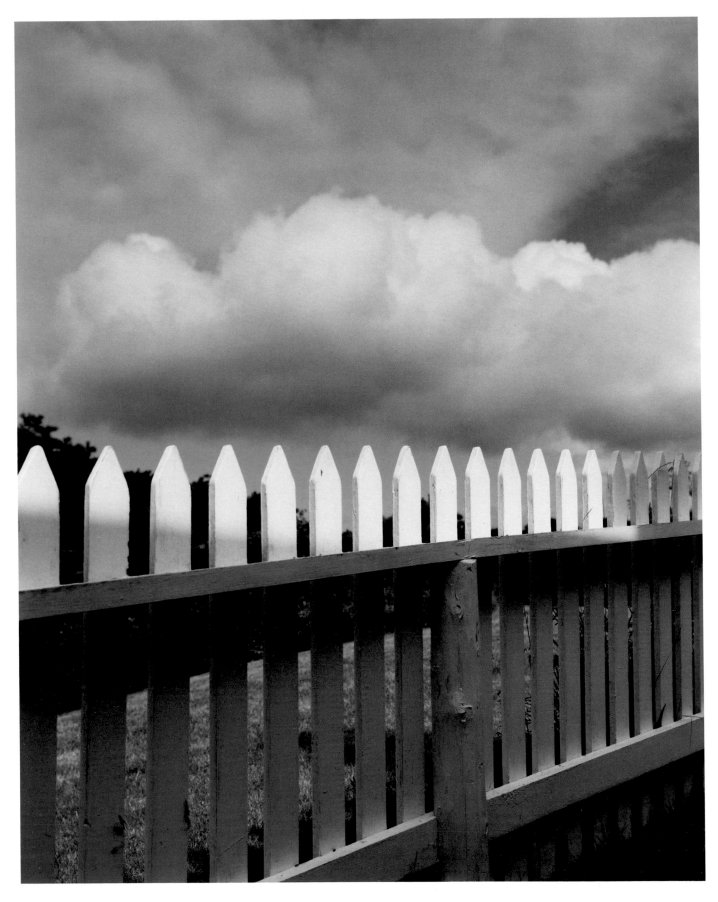

Joel Meyerowitz, *Truro, Cape Cod,* 1976

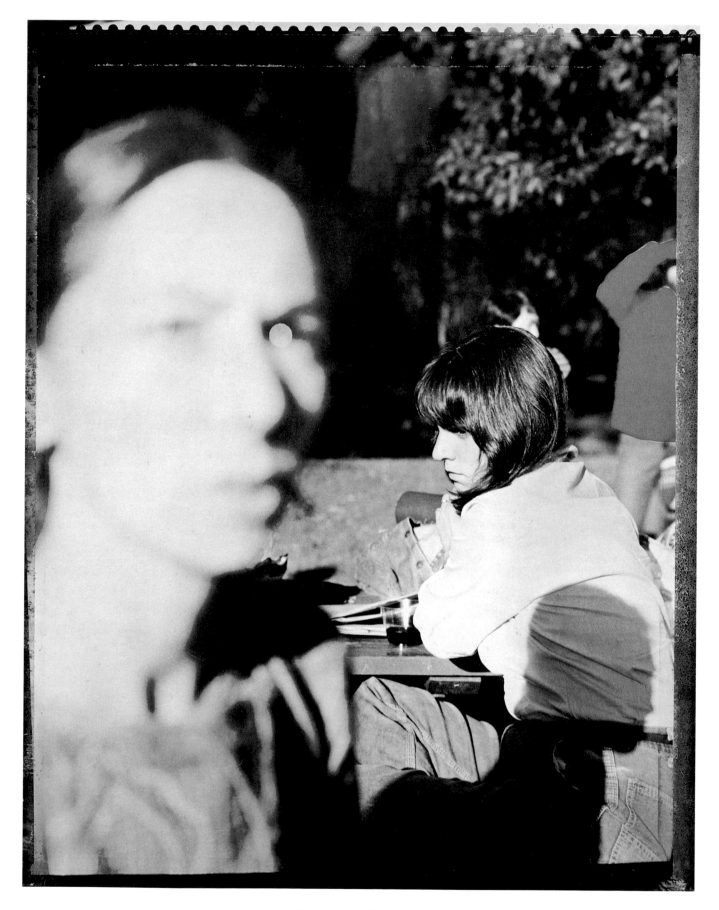

Joan Lyons, untitled, 1980

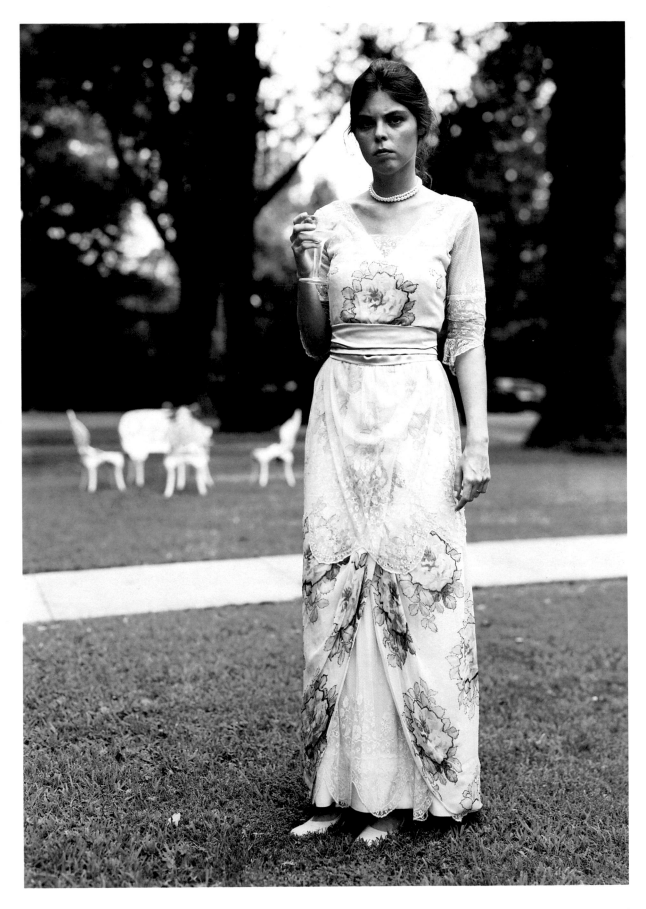

William Eggleston, *Shelly Schuyler, Sumner, Mississippi*, c. 1973

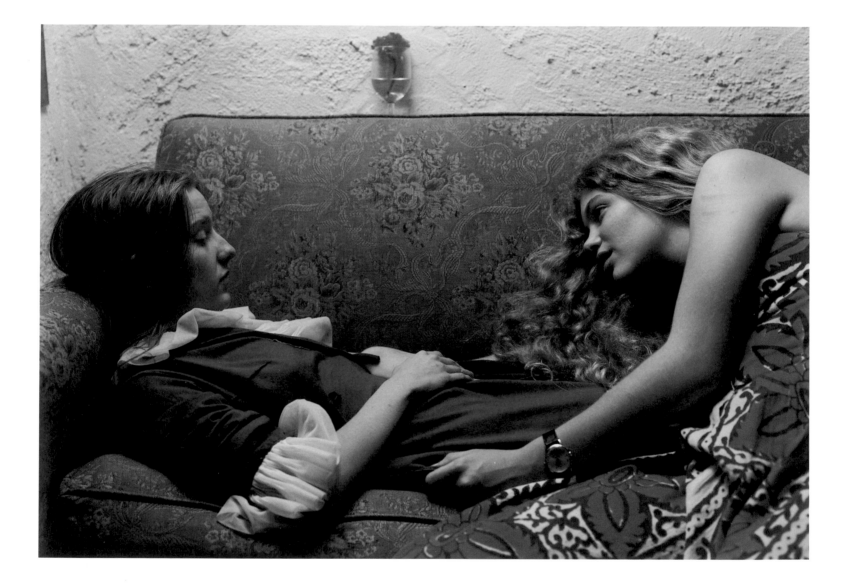

above: William Eggleston, *Two Girls,
Memphis, Tennessee,* 1973
opposite: Jo Ann Callis, *Man in Tie,* 1976

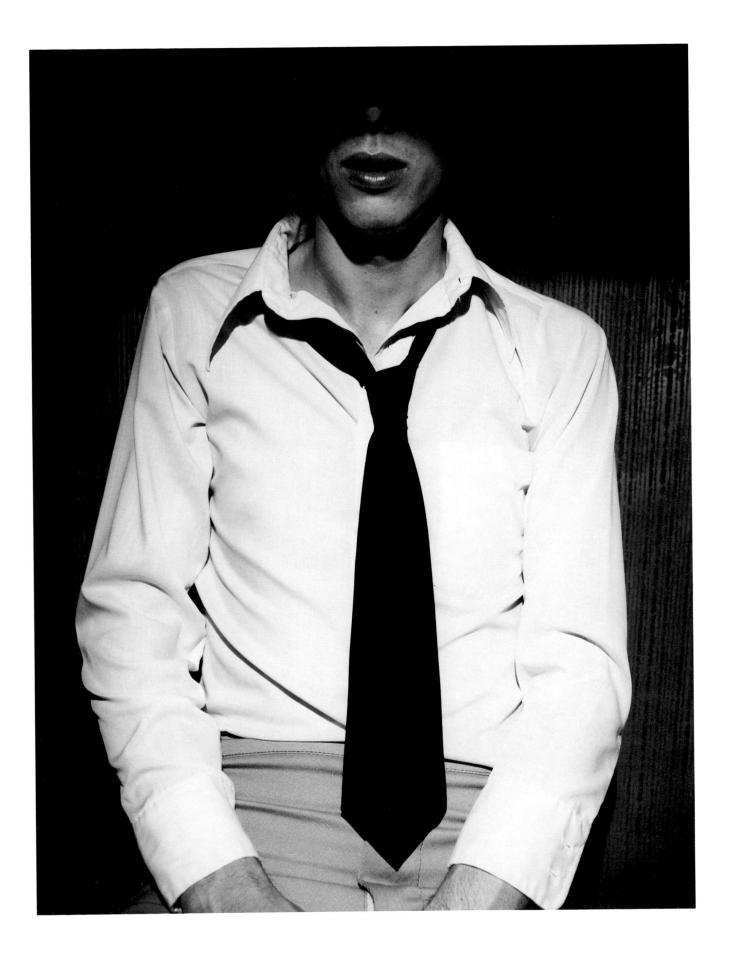

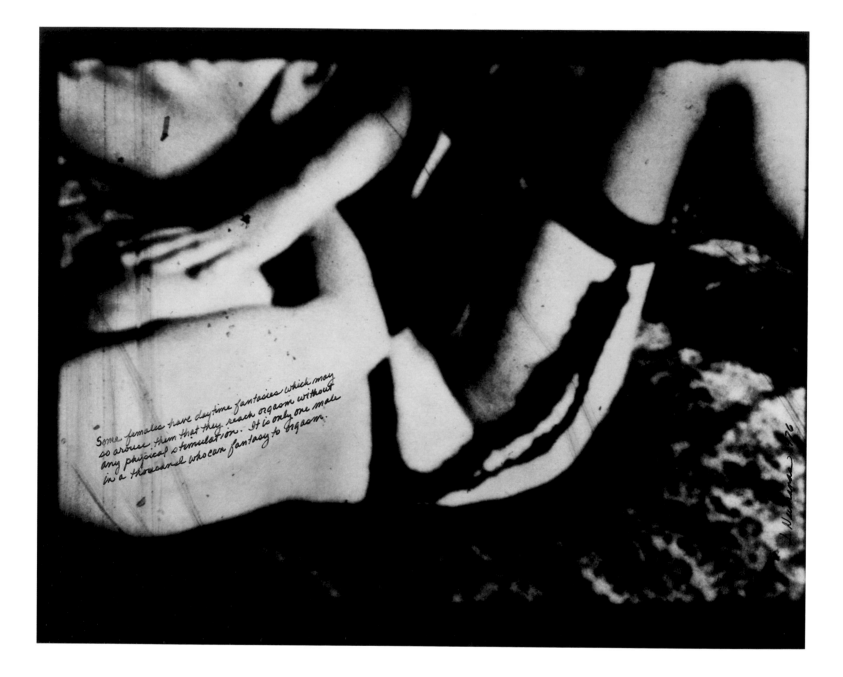

above: Joyce Neimanas, *Some Females Have Daytime Fantasies . . .*, 1976
opposite: Judith Golden, untitled, 1977

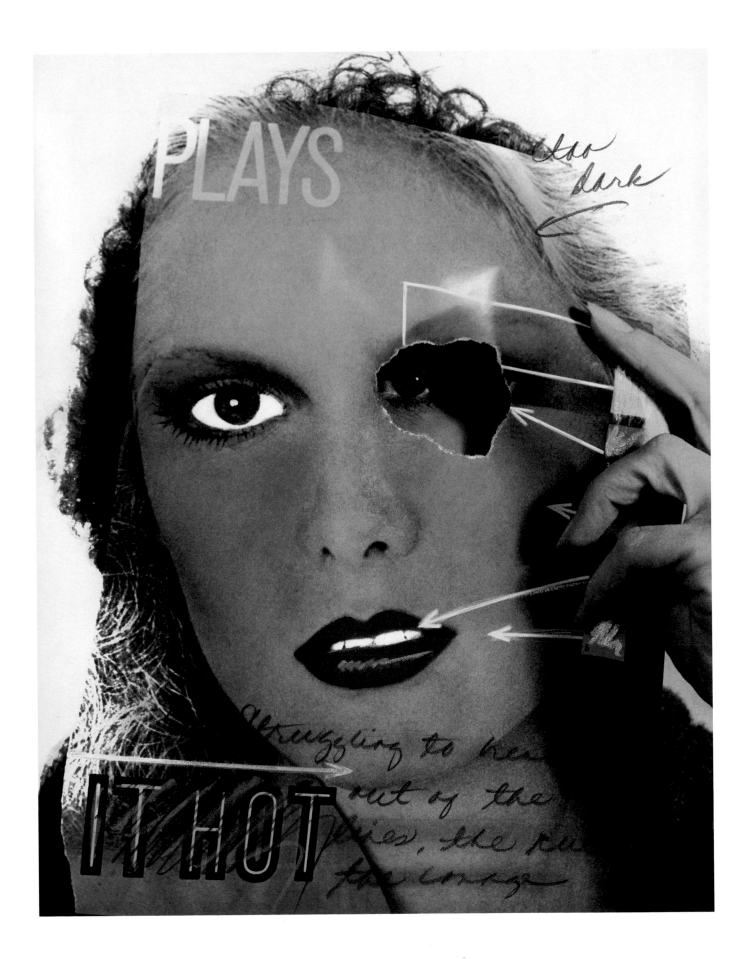

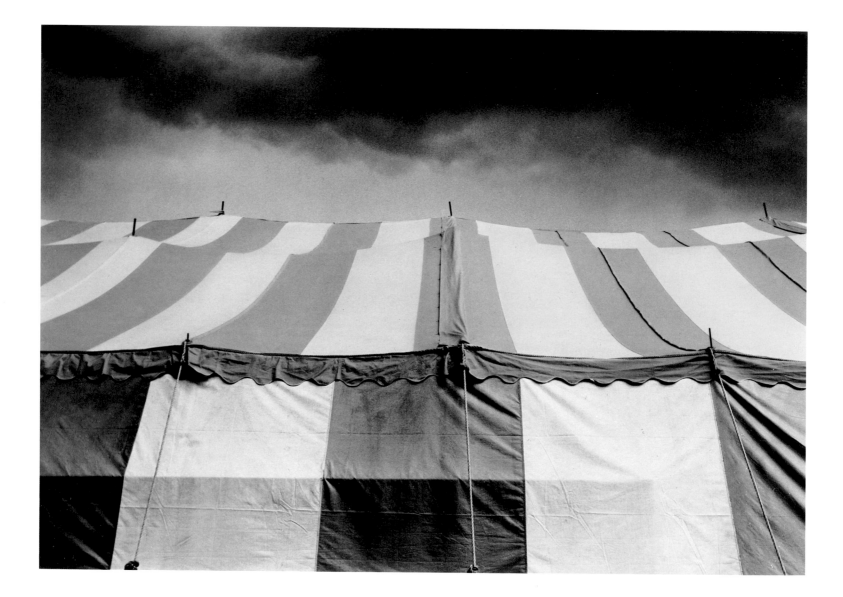

above: Christopher P. James, *Tent/Sky ''B'' No. 4,* 1977
opposite: Reed Estabrook, *Exercise in Solid Geometry No. 31,* 1981

above: James Henkel, *Guatemala/Minnesota,* 1979
opposite, top: Lawrence J. Merrill, untitled, 1982
bottom: Brian Albert, *Foghat/Wet Willie Concert, St. Paul,* 1978

William Christenberry, *5¢ Sign, Demopolis, Alabama*, 1978

Len Jenshel, *World Trade Center, New York, New York*, 1979

Stuart D. Klipper, *Beach, Los Angeles,* 1976

ACKNOWLEDGMENTS The purpose, substance, and life of a museum are its collections. Since the turn of the century, the directors, curators, and staff of The Minneapolis Institute of Arts have worked in concert with many donors to fashion a truly encyclopedic art collection for the residents of Minnesota. So, too, the photography collection at the museum has grown through generous donations of monies and works of art. Most importantly, the continuing assistance of Kate and Hall J. Peterson, whose original gift of discretionary purchase funds in 1971 gave momentum to an assertive program of acquisition, remains at the center of the department's purchase capability. The following contributors are to be thanked as well: D. Thomas Bergen, Christopher Cardozo, Arnold H. Crane, Mrs. Julius E. Davis, Harry McC. Drake, Arnold Gilbert, Lee Kitzenberg, Julia Marshall, Herbert R. Molner, Joanna Steichen, Virginia Zabriskie, and others too numerous to list here. The majority of contemporary photographers represented in the collection have also given photographs and, through their active participation and help, have greatly added to our holdings of their works. The Photography Council, the support and advocacy organization for the Photography Department, has provided funds for the purchase of an outstanding group of images by contemporary photographers. Corporate donations, notably by AT&T, have been of major consequence as well.

Just as significant for the growth of the collection has been the encouragement provided by the three museum directors under whose tenure it was formed: Carl J. Weinhardt, Anthony Morris Clark, and Samuel Sachs II. The collection's most dramatic growth in size, scope, and quality has occurred during the past ten years under the leadership of Sam Sachs, who continues to give so freely of his time and advice.

The National Endowment for the Arts has been a primary source of funding for the purchase of work by American photographers as well as for this publication to document the Institute's photography collection. The NEA grant for this catalogue was awarded on a matching basis and supported by contributions from the Cowles Foundation, Ned Dayton, Jonas and Betsy Dovydenas, Harry McC. Drake, Michael G. and Ann Ginsburg Hofkin, John and Marsha Levine, Julia Marshall, Walter R. McCarthy, Don McNeil, the Andrew W. Mellon Foundation, Virginia P. Moe, Mr. and Mrs. Fred Rosenblatt, Frederick Scheel, Janet and Otto Seidenberg, Carl Sheppard, Mr. and Mrs. C. Steven Wilson, and anonymous donors.

As far as the actual preparation of the catalogue itself, I am indebted to the staff of Aperture and specifically to Carole Kismaric, editor; Mary Wachs, copy editor; Wendy Byrne, designer; and Michael Hoffman, publisher, who together have been my bulwark and sustenance throughout this project. My special thanks go to my past and present curatorial assistants Mary Virginia Swanson and Christian A. Peterson who researched the museum's photography holdings and to Christian, in particular, whose painstaking cataloguing of the collection resulted in the detailed listing included in the catalogue edition. I am also grateful to Sandra L. Lipshultz, writer/editor on The Minneapolis Institute of Arts' staff, who has edited the manuscript with patience and thoroughness, and to Louise Lincoln, editor, who has coordinated the production of the book. The staff at Meriden Gravure, too, has been an inspiration. Their devotion to their art and craft and the guidance they have provided in helping to realize this publication have been unique in my experience. Bob Hennessy, who made the half-tone negatives, is certainly one of the photographic artists that this catalogue means to celebrate.

But of all these people, one in particular deserves special tribute: Anthony Morris Clark. The director of The Minneapolis Institute of Arts from 1965 to 1974 and a scholar of high professional distinction, Tony was rigorously art historical and an unlikely candidate to promote and facilitate the beginnings of a collection of photographs at this museum. It could have been expected that a specialist in 18th-century Italian painting would find little of interest in photography as an art. "Not much substance there," he might have thought and "almost no history comparatively speaking." But Tony was not such an unbending expert closed to other viewpoints and concerns. Instead, like the best administrators, he appropriated the necessary purchase funds to acquire the photographs that I found and successfully defended and then secured the approval (if not the altogether enthusiastic acceptance) of the trustees' accessions committee. He was particularly successful in gaining the support of Hall J. Peterson and his wife Kate Butler whose purchase fund has, as already mentioned, been crucial to the formation of the collection. So it is with the deepest respect and appreciation that I dedicate this book to the memory of Tony Clark—curator, director, advocate, and friend.

TEXT CREDITS Quote page 97 by Richard Avedon from Avedon [exhibition catalogue], The Minneapolis Institute of Arts, 1970. Quote page 111 by André Bazin from What Is Cinema?, vol. 1, The University of California Press, Berkeley, 1967, pp. 9–16. Quotes pages 58 and 65 by Walker Evans from Quality: Its Image in the Arts, Louis Kronenberger, editor, Atheneum, New York, 1969, pp. 169–71. Quote page 77 by Robert Frank from "Statement," 1958. Quoted in Photography in Print: Writings from 1816 to the Present, Vicki Goldberg, editor, Simon and Schuster, New York, 1981, p. 401. Quote page 136 by William M. Ivins, Jr., from Prints and Visual Communication, by William M. Ivins, Jr., Harvard University Press, Cambridge, 1953, p. 134. Quotes pages 23 and 29 by A. Hyatt Mayor from "The Photographic Eye," The Metropolitan Museum of Art Bulletin, Summer 1946. Reprinted in A. Hyatt Mayor: Selected Writings and a Bibliography, The Metropolitan Museum of Art, New York, 1983, pp. 77, 79. Quote page 120 by Piet Mondrian from De Stijl, vol. 1, 1918. Quoted in Art and Act, Peter Gay, Harper and Row, New York, 1976, p. 196. Quote page 70 by Aaron Siskind from "Credo." Prepared for the exhibition "51 American Photographers," seen at The Museum of Modern Art, 1950. Quoted in Aaron Siskind: Pleasures and Terrors, by Carl Chiarenza, New York Graphic Society, Boston, 1982, p. 88. Quote page 12 by John Szarkowski from The Photographer's Eye, The Museum of Modern Art, New York, 1966, p. 11. Quote page 40 by Forbes Watson from a review of Paul Strand's photographs in 1925 exhibition, "The World." Quoted in Paul Strand: Sixty Years of Photographs, Aperture, Millerton, New York, 1976, p. 151. Quote page 73 by Edward Weston from "Photography—Not Pictorial," Camera Craft, vol. 37, no. 7, 1930. Reprinted in Photographers on Photography, Nathan Lyons, editor, Prentice-Hall, Inc., Englewood Cliffs, New Jersey, 1966, p. 156. Quote page 83 by Garry Winogrand from Garry Winogrand: A Portfolio of Fifteen Photographs, The Double Elephant Press, New York, © 1974 Estate of Garry Winogrand.

PHOTO CREDITS Page 66 by Ansel Adams courtesy of the Ansel Adams Publishing Rights Trust. All Rights Reserved. Pages 92-3 by Diane Arbus © the Estate of Diane Arbus. Page 69 by Wynn Bullock courtesy Wynn and Edna Bullock Trust. Page 89 by Arnold H. Crane © Arnold H. Crane. Page 41 by Imogen Cunningham © The Imogen Cunningham Trust. Pages 139-40 by William Eggleston © William Eggleston. Pages 59-64 by Walker Evans courtesy of the Walker Evans Estate. Page 77 by Robert Frank from The Americans by Robert Frank, Aperture, Millerton, New York, © 1969 Robert Frank. Page 148 by Len Jenshel courtesy H.F. Manès Gallery, New York. Page 51 by Jacques Henri Lartigue © 1984 S.P.A.D.E.M., Paris/V.A.G.A., New York. Page 40, 88 by Arnold Newman © Arnold Newman. Page 135 by Tod Papageorge © 1976 Tod Papageorge. Page 115 by Eve Sonneman courtesy Eve Sonneman and Leo Castelli Gallery, New York. Pages 52-3 by Edward Steichen © Joanna T. Steichen. Pages 42-3 by Paul Strand © 1982 The Paul Strand Foundation, Millerton, New York. Pages 38-9 by James Van DerZee © Donna Van DerZee. Page 68 by Edward Weston © 1981 Arizona Board of Regents, Center for Creative Photography. Page 71 photograph by Minor White. Reproduction courtesy The Minor White Archive, Princeton University, © 1982 Trustees of Princeton University.

Design by Wendy Byrne. Composition by World Composition
Services, Inc., New York. Duotone printing by Meriden Gravure,
Inc., Meriden, Connecticut. Color printing by Beck Offset Color Co.,
Pennsauken, New Jersey. Bound by Publishers Book Bindery, Long
Island City, New York. Printed in the United States.

Library of Congress Catalogue Card Number: 84-70445.
ISBN: 0-89381-157-2 cloth edition; 0-89381-163-7 catalogue edition.

Aperture publishes books, portfolios, and a periodical to
communicate with serious photographers and creative people
everywhere. A complete catalogue will be mailed upon request.
Address: Millerton, New York 12546.